MINIBEASTS WITH JESS FRENCH

BLOOMSBURY WILDLIFE
LONDON · OXFORD · NEW YORK · NEW DELHI · SYDNEY

CONTENTS

LOVE

INTRODUCING MINIBEASTS

Before we begin our adventure into the fascinating world of minibeasts, here's a quick note about the slightly more boring science of taxonomy. To make sense of our amazing world, scientists have devised excellent ways of classifying how all our different creatures fit together by sorting them into separate groups. Invertebrates – which are animals lacking a backbone – are broadly classified into the categories below, according to how complicated their tissues and body systems are.

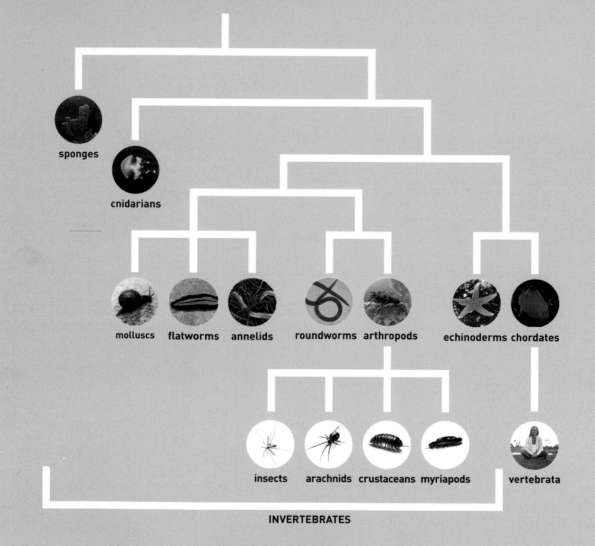

sponges

cnidarians

molluscs flatworms annelids roundworms arthropods echinoderms chordates

insects arachnids crustaceans myriapods vertebrata

INVERTEBRATES

The word 'minibeast' has no place in science – it's a non-taxonomic term, so there are no strict rules about what it does and doesn't include, and scientists seem to dislike it. However, I think it's the perfect word to describe the fascinating and bizarre species that populate the minute invertebrate world. It depicts these animals precisely as they are: tiny, enchanting monsters with huge characters and incredible superpowers.

My definition of minibeast can be stretched to cover any of the invertebrates that fit into this taxonomic tree on the left, but I have spent vastly more time studying arthropods, annelids, flatworms and molluscs than any of the other, more obscure groups. That's quite simply because those are the easiest minibeasts to observe (I don't often come across sponges, jellyfish and single-celled organisms in my day-to-day minibeast interactions!). If you're interested to learn more about the other phyla on the taxonomic tree, I've included short definitions for them within the glossary on page 124, where you'll also find definitions for other specialist minibeasts terms I use throughout this book.

The four invertebrate groups I'm going to focus on in this book are:

Arthropods are invertebrates with exoskeletons. This external skeleton allows them to have jointed appendages and survive in dry areas, but it also means that they must periodically moult their skin in order to grow. Arthropods are further divided into groups depending on the number of legs they have:

Insects (6 legs)

Arachnids (8 legs)

Crustaceans (10–14 legs)

Myriapods (more than 20 legs)

Annelids are segmented worms, such as earthworms, ragworms and leeches. They don't have legs or a hard skeleton, and their bodies are split into many small segments. They are excellent swimmers and burrowers, which means they can live in freshwater, marine and terrestrial environments. They are extremely sensitive to drying out, so they cannot survive in areas with little moisture.

Flatworms are ribbon-shaped, flat-bodied worms. They have a very basic body plan, with no respiratory or circulatory systems and a crude nervous system. Many flatworms are parasites that live in or on other animals.

Molluscs are soft-bodied invertebrates that sometimes have calcium carbonate shells. They generally don't have any segments and often have a tongue mounted with hundreds of tiny teeth, called a radula. Some molluscs, such as slugs and snails, have one big, muscular foot. Other molluscs, such as squids and octopuses, have multiple tentacles.

Minibeasts are a wildly diverse and successful bunch, and are found almost everywhere in the world. Although individually small, the minibeast total population and biomass vastly outnumbers that of their vertebrate counterparts. These are the species that shape the way our planet looks, functions and perpetuates – they pollinate plants, decompose dung, spread seeds, and provide food for birds, fish and mammals. Without invertebrates our world simply would not function.

Not only are minibeasts vital to the running of our planet, but they also demonstrate behaviours that are virtually unbelievable. While I could dedicate this entire book just to the ecological importance of minibeasts, instead I hope to introduce you to some of the weirdest and most fascinating members of the minibeast world, and to expose you to a few of their strangest behaviours through the breathtaking photos, masses of amazing facts and profiles of incredible species in the pages ahead. So let's dive into the mindblowing world of the minibeast!

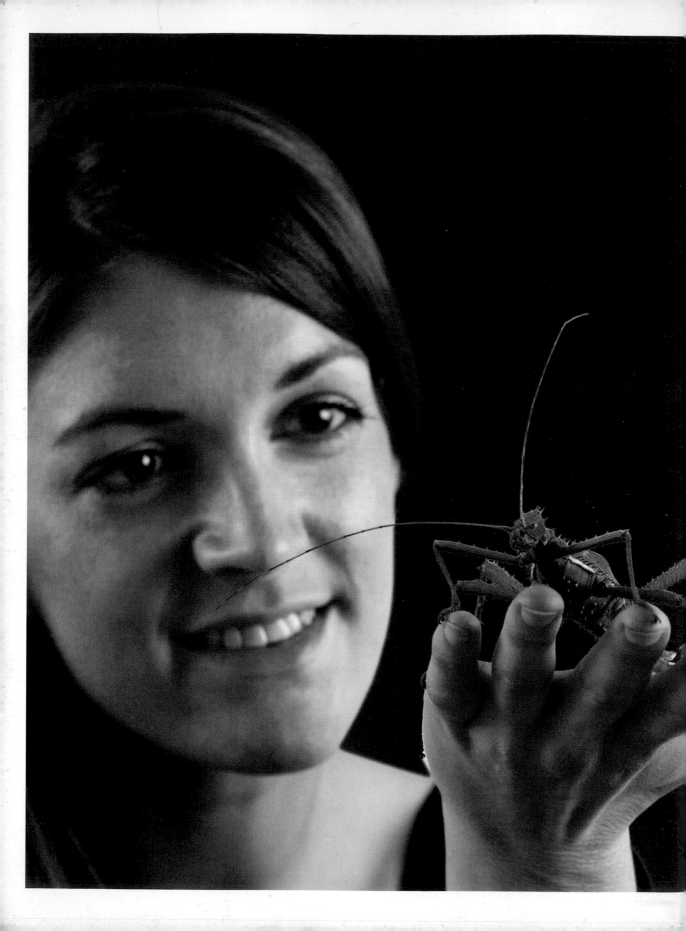

EAT

Invertebrates can be found almost everywhere on the planet, so it is no surprise that they've adapted to exploit an incredible array of food sources. We commonly associate minibeasts with the destruction of crops, but there are many ingenious invertebrates that feast on much more interesting foodstuffs than lettuces and tomatoes!

There are minibeasts with fantastic mouthparts that help them get their food, yet the most basic of invertebrate digestive systems is little more than a sack and a hole. The hole allows food to enter and leave the body, and the sack is full of enzymes that digest the food. More complex minibeasts have two holes, connected by a tube. The most intricate of invertebrate body systems include sensory palps – cutting, shearing and sucking mouthparts – and the ability to tolerate and recycle toxins.

Acquiring food isn't a simple task for all minibeasts; some invertebrates have to eat constantly to gain enough energy to stay alive. These minibeasts usually rely on foods that are plentiful and easy to find. Others must use more sophisticated techniques to locate and obtain their menu of choice. Some find the food they need in their local environment, while others must travel hundreds of miles in search of their next meal.

Whether acting solo or as a carefully coordinated group, opportunistic minibeasts have managed to squeeze their meals out of just about every habitat on Earth.

MOUTHPARTS

Through our ability to cook, chop, blend and peel, humans are able to consume a vast array of foodstuffs, despite having relatively unspecialised mouthparts. Minibeasts do not have the luxury of eating with cutlery or pulverising their food in a food processor before consuming it. So their diets are generally restricted by their mouthparts, which are often specialised to exploit very specific dietary niches.

STRAIGHT PROBOSCIS

Although the long, thin needle protruding from the face of the bee fly looks formidable, this needle (called a proboscis) is actually used for probing deep inside the nectar tubes of flowering plants. Like a long and pointy drinking straw, the middle of the tube is hollow and allows the bee fly to suck up nectar from inside the plant. In some species, the bee fly's proboscis can be more than four times the length of its head!

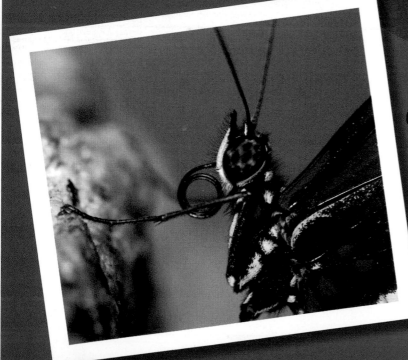

CURVED PROBOSCIS

Much like the bee fly's nectar straw, the proboscises of moths and butterflies are also used for sucking up the sweet liquids from deep inside flowers. However, unlike the bee fly, butterflies and moths carry their proboscises curled neatly under their heads.

HOLLOW JAWS

The huge and powerful jaws of the great diving beetle larva allow it to catch prey much bigger than itself. These enormous jaws are hollow, which enables the great diving beetle larva to inject digestive juices into its prey and suck out its victim's insides without ever having to let go.

FILTER FEEDER

Mosquito larvae feed by using the bristly brushes surrounding their mouthparts to strain out algae, plankton, bacteria and other micro-organisms that are suspended in water. This method of feeding is called filter feeding, and is also employed by clams, krill, flamingos and even some whales.

SPONGE TONGUE

Flies' tongues are like mops on the end of tubes, which allow them to soak up pools of liquid. If a potential food source is not yet in a liquid state, the fly can vomit up digestive juices through the tube in order to liquefy the food, so that it may be sponged up by the tongue-mop.

BUG BEAKS

The word 'bug' is used for lots of different minibeasts, but 'true bugs' are actually a type of insect in the order Hemiptera. Common to all Hemiptera are their piercing and sucking mouthparts. The vast majority of bugs use these sharp beaks to suck plant sap, but some use them to spear other insects and even to suck blood.

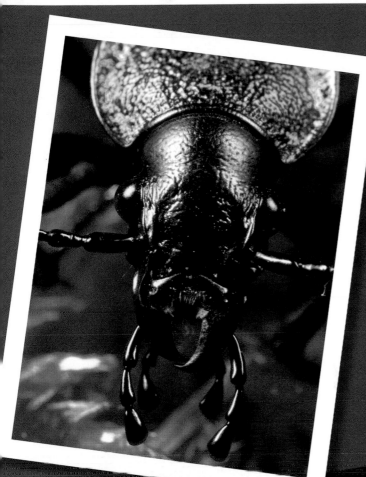

CHEWING AND CUTTING

Minibeasts that eat tough material, such as wood or the exoskeletons of other minibeasts, need large and robust jaws with sharp and serrated blades. Beetles, grasshoppers, crickets, praying mantises and dragonflies all have jaws designed for crushing and tearing hard foodstuffs.

MULTITOOL MOUTHPARTS

Bees combine components of various other species' mouthparts, allowing them to both chew and suck. They have a long tongue covered in long hairs. When they're ready to drink nectar, the mouthparts surrounding the tongue form a sucking tube. The tongue stretches down through the tube to suck the liquid. Bees also have dextrous jaws that, among other tasks, they use for digging nests and moulding wax.

FINDING FOOD

It doesn't take much effort or brainpower for people to locate the source of their next meal. With supermarkets and fast-food restaurants on every corner of every city, access to an enormous selection of culinary delights is only restricted by price. Minibeasts do not have it so easy. Despite the fact that – for herbivorous minibeasts, at least – food literally does grow on trees, the world is a big place to a tiny insect and it can take a great deal of searching to find their next meal.

FOOD DANCE

When foraging honey bees return to the hive, they communicate the location of the food sources they have discovered through dance. They perform two types of dance: the round dance and waggle dance.

The **round dance** signifies food sources that are close to the hive. The returning honey bee doesn't disclose directional information but merely shares out some of the nectar it has found and encourages more workers to leave the hive to look for it.

The **waggle dance** signifies food sources more than 100m (328ft) from the hive. The steps of the waggle dance are simple; the returning forager waggles its abdomen repeatedly as it moves in a figure-of-eight pattern. The length of time the dance lasts relates to the distance between the hive and the food source. It also waggles its body at an angle, which signifies where the food source is relative to the sun's position.

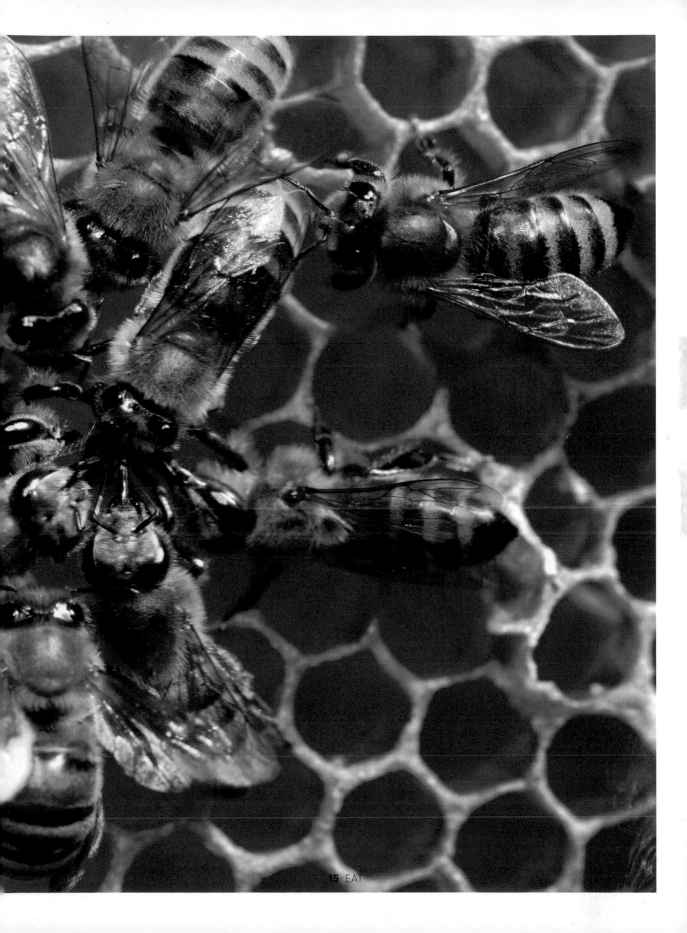

LAYING A TRAIL

Within ant colonies there are groups of female workers whose job it is to find food for the colony: they're called scouts. Every day, scouts set out randomly to search for food. When the scout finds something edible, she touches it all over her head and mouth, sometimes eating a little piece. Then she returns directly to the colony, laying a stinky trail of pheromones as she does so. When other scouts come across the pheromone trail, they follow it to the food source, pick up some food, then return to the nest, dropping more pheromone along the trail and reinforcing its scent. Some species of ant can alter the concentration of pheromones in the trail depending on the quality of the food source. More and more ants continue to join the trail until the food is totally gone and the pheromone trail eventually fades away.

SOCIAL INSECTS

Insects are considered 'social' if they do the following three things:

1 Work together to raise young
2 Live together in colonies of many generations
3 Divide up jobs between different castes.

CASTES

Many social insects, such as ants, bees, termites and wasps have developed caste systems, which means that individuals within the colony split into groups according to their jobs. Sometimes, members of different castes of the same species can have completely different bodies. For example, some soldier ants are much bigger and stronger than other workers from the same colony.

DID YOU KNOW!

Sometimes, instead of breaking down their food into small pieces that they can transport back to the nest individually, ants work together to carry huge items. This requires excellent communication and careful coordination – like helping your friends to move a sofa up a flight of stairs!

ULTRAVIOLET SIGNPOSTING

Compared with the rest of the animal kingdom, humans have pretty decent eyesight. We are lucky enough to appreciate the bright colours of flowers and fruits. But have you ever considered how a flower looks to a pollinator? Many insects see an even greater range of colours than we do, especially in the range of ultraviolet (UV). Plants have exploited this insect superpower by covering themselves in UV patterns that lead straight to their nectar. These 'nectar guides' ensure that insects make a beeline for the areas of the plant where they will be covered in the most pollen possible.

SWARMING

One of the most extreme searches for food comes in the form of locust swarms. These are vast hordes of hungry insects scouring the earth for suitable feeding grounds. 'Locust' is not a species but rather the name for a short-horned grasshopper that it is in swarming mode. When they're not in their swarming phase, these grasshoppers are solitary, existing in low numbers across the desert and avoiding other members of their species as much as possible. It's only when the rains come that life changes for these **lonesome hoppers**. As food springs up around them, the rate of feeding and breeding of the locusts multiplies exponentially. When the grasshoppers become overcrowded, their behaviour changes, triggered by their hind limbs being constantly jostled. This causes a change in their bodily serotonin levels, making them much more sociable. They begin to congregate in enormous groups. Once the new generation of gregarious grasshoppers become adults, they adopt a swarm mentality and take to the sky, migrating in their millions in the direction of the prevailing wind, on the hunt for food. The swarms often stretch for kilometres in length and can block out the sun to the land below them. Once the locusts locate a patch of vegetation, they feed voraciously, often causing widespread damage to agricultural crops.

INGENIOUS FEEDERS

Even for a herbivore, it is not always as simple as finding the nearest plant. Some plants are poisonous, some are even carnivorous, and some insects live in extreme conditions where plants only flower for half the year. Amazingly, minibeasts have found ways to exploit even the most extreme of conditions.

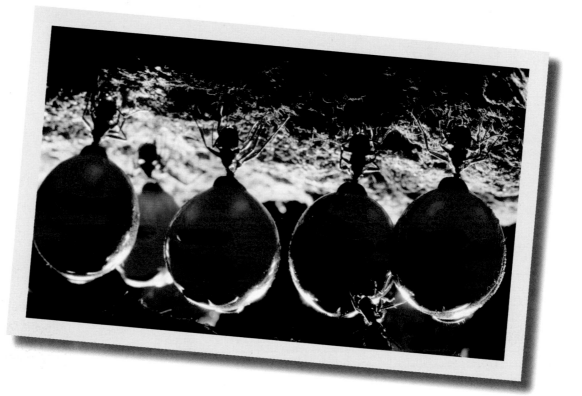

LIVING LARDERS

It is well known that certain animals collect extra food in times of plenty to feed on when supplies run low. This behaviour is called larder hoarding and is demonstrated by many types of animals, including squirrels, moles, wildcats and harvester ants. Food is usually hidden in an underground larder up to visit at a later date.

Honeypot ants store their larders in quite a different way. During the wet season, worker ants forage for sweet nectar, honeydew and dead insects. When the workers find a food source, they feed on it before returning to the nest. Upon their return, they regurgitate their findings into the expectant mouths of another type of worker called a replete. Repletes hang from the roofs of honeypot ant nests. Their sole purpose in life is to provide a living larder, **storing sweet liquids in their elastic abdomens** until the dry season when food is scarce. As soon as the vegetation outside begins to dry up, the worker ants retreat to the nests full time and survive off the sweet liquid they have stored in the huge swollen abdomens of their repletes.

AMAZING FACT!

Honeypot ants gorged on nectar can swell to the size of grapes! The nutrient-rich sugary liquid inside these living food storage vessels is eaten by some indigenous tribespeople as well as by other honeypot ants.

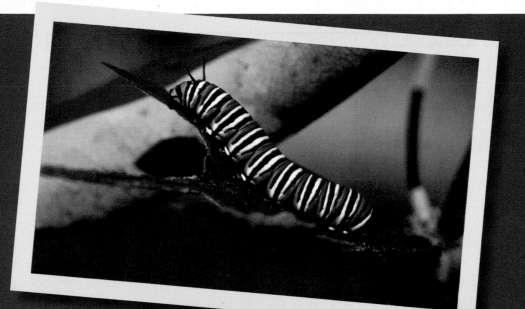

PROTECTIVE POISON

Milkweed does its best to discourage insects from eating it. Its leaves are hairy, it oozes sticky white latex (which is what gives milkweed its name) from its veins and its sap is full of cardiac glycoside, a potent poison to most birds and mammals. You might expect any one of those factors to prevent milkweed from becoming dinner for any sensible insect. But as with most plant protective mechanisms, there are resourceful insects that have evolved specifically to exploit them. Not only have milkweed feeders such as monarch butterfly caterpillars and milkweed bugs evolved to digest toxic milkweed leaves without becoming ill, they also **inherit their poisonous properties**, providing the insects with an excellent chemical defence against predators. Even the sticky latex that oozes from the veins of milkweed leaves isn't a problem to those that have evolved to live on them. Normally, high pressure drives the latex system and causes milky glue to burst into the face of any insect trying to eat its leaves, gluing its mouthparts. But milkweed feeders know how to disarm this system. By chomping through the main canal of the latex delivery system at the centre of the leaf, they reduce the pressure and stop the latex flowing to certain areas, which they are then free to devour.

AMAZING FACT!

Caterpillars must eat almost constantly for their entire lives. In contrast, after a decent blood meal the medicinal leech can survive without eating for a whole year!

SPECIES PROFILE

ARIXENIA SPECIES

DISTRIBUTION South-east Asia

SPECIAL SKILL Lives in the skin folds of the naked bulldog bat and feeds off its bodily secretions.

ARMS RACE

The story of green cloverworm caterpillars and their relationship with the clover plants they feed on is a great example of an evolutionary arms race. An arms race starts when one species evolves an adaptation over the other. Over millions of years, the second species evolves a counter-adaptation, and so it continues.

Clover plant adaptation:
The plant releases a chemical to attract wasps when Green cloverworm caterpillars damage its leaves. The wasps are parasites of the cloverworm caterpillars: they lay their eggs inside the caterpillars' bodies.

Cloverworm counter-adaptation:
The cloverworm flings itself off the leaf when a wasp comes near, releasing a line of silk that will later allow it to climb back to the leaf and to safety.

First wasp counter-adaptation:
The parasitic wasp abseils down the cloverworm's silk lifeline and lays its eggs in the caterpillar at the bottom.

Second wasp counter-adaptation:
A different species of parasitic wasp recognises when a cloverworm caterpillar has been parasitised and hauls it back up to the leaf. Then it injects its own eggs, which hatch into larvae that are parasites of the offspring of the first wasp!

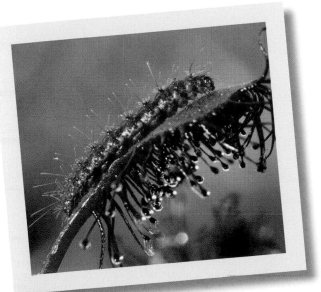

STICKY BUSINESS

Sundews are carnivorous plants that supplement their nutrient-poor soil by eating insects. Sundews have sticky hairs on their leaves, which attract insects and then trap them, so that the plant can digest them. Sundews are **very efficient insect killers**. They successfully capture almost all small insect species that cross their path. Except, that is, for the caterpillars of the sundew plume moth. In the dead of night, these tiny caterpillars set about removing the sticky central hairs of the sundew's leaves, avoiding contact with the gluey liquid by eating it and mopping it up with their bristly hairs. Once an area is cleared, the caterpillar begins to eat the leaf itself, sometimes feasting on the partially digested insect leftovers that remain.

FARMERS

Learning to farm plants and livestock was a pivotal point in human development. It allowed nomadic tribes to stay in one place and led to the creation of the first villages and towns. But farming is not a uniquely human invention. Millions of years before the first human agricultural settlements, farming was already happening – albeit on a much smaller scale.

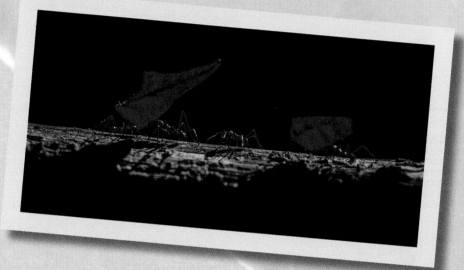

FUNGUS-FARMING ANTS

Farming fungus is a relatively common practice among ant species of tribe Attini. Most well known among the fungus farmers are the leafcutter ants, which can famously carry up to 5,000 times their own body weight in fresh vegetation. These leaves are taken to their farms, which can be located anywhere from cavities beneath stones to inside rotting wood or under tree bark. The farms are vast and complex; they can be up to 9m (30ft) deep and can extend for hundreds of metres. They often have their own ventilation systems to allow fresh air to enter.

Inside the farms, leaves are chewed into tiny pieces and used as a substrate on which to grow fungus. **Other ant species also use insect poo and dead insects as manure**, with each species of ant having their own preference. Ants are particularly skilled at maintaining pure fungal cultures, due to their compulsive cleaning, their meticulous swabbing of the surfaces of all plant material that is brought into the farm, and the antibiotic-producing bacteria that grows on the ants' skin. The warm and humid ant nest provides the perfect conditions for fungal growth, and the fungus spreads rapidly. The ants regularly remove the cuttings and feed them to their growing ant larvae.

AMAZING FACT!

When a new queen leafcutter leaves to start a new colony, she stores a little pellet of fungus in a special fungus pouch in her mouth. She then fertilises the pellet with her own poo when she starts her new colony.

SYMBIOSIS

When two species have a close association with one another, we call their relationship symbiotic. There are three types of symbiotic relationship:

Mutualistic: Both species benefit from the relationship (below left).
Commensal: One species benefits and the other is unaffected by the relationship (below centre).
Parasitic: One species benefits and the other suffers as a result of the relationship (below right).

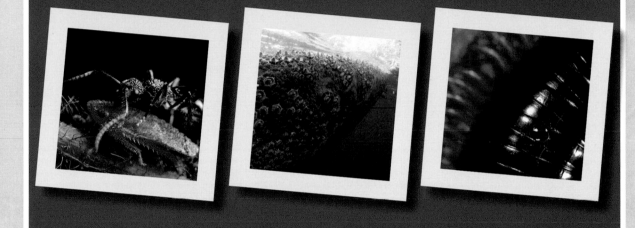

FUNGUS-FARMING BEETLE

Ants are not the only minibeasts to farm fungus – marsh snails, termites and beetles have all independently evolved the same behaviour. Ambrosia beetles are wood-boring, fungus-farming beetles. Fungus is their sole diet. It's a smart move: wood is poor in nutrients and often full of toxins that trees produce to deter insects from eating their bark. In contrast, fungus is highly nutritious, containing amino acids, vitamins and sterols. Upon locating a suitable tree – usually full of decaying or recently dead wood – ambrosia beetles excavate a system of deep tunnels, leaving a column of sawdust in their wake. Once inside, they plant their fungal spores and wait for them to grow. When the cultivation is well underway, the female beetle lays her eggs. Both the developing larvae and adults feed off the fungus until the larvae mature. Once the larvae turn into adults they leave the fungus farm, loaded with fungal spores, in search of their own tree-trunk plot.

APHID-FARMING ANTS

Aphids are bugs, with piercing, sucking mouthparts. They also have a very sweet tooth. Conveniently, their pointed beaks are perfectly designed to tap into the plant's main food transport system, the phloem. In the stem, where aphids usually feed, the sugary sap is at very high pressure, and far more liquid flows into the aphids' beaks than they could ever consume themselves. So they use the excess liquid as a bargaining tool, to employ the **body-guarding services** of the black garden ant. The ants drink the sweet honeydew directly from the aphids' anuses, carrying and herding them to the most productive areas of sap. Although at first it may seem that this is a mutually beneficial situation, scientists studying the relationship have discovered that the ants produce chemicals that sedate the aphids, and may even prevent their wings from growing so they can't fly away. Some ant farmers even bite off their aphids' wings to keep them under control.

BACTERIA-FARMING CRAB

It is hard to imagine anywhere less hospitable than the freezing waters of Antarctica. Yet 2,000m (1.2 miles) under the icy continent, hydrothermal vents provide a hot spot that the yeti crab calls home. Unsurprisingly, little else can survive there, so this crab has had to get creative with its foraging methods. The distinctive hairy arms that give the yeti crab its name are as functional as they are fashionable. The dense coat of hairs is a breeding ground for bacteria, which the crab uses to supplement its diet of any other creatures it can get its claws on.

POLLINATION

Many plants entice minibeasts with irresistible offers of food, mating sites, heat or perfume, but these rewards usually come at a price. For a plant, anchored to the ground by roots, sexual reproduction can be difficult. Its pollen must be delivered to another plant either by insects or the wind or sometimes by reptiles, birds and mammals, and humans can pollinate plants by hand. Although wind pollination is free, it isn't very effective. Insect pollinators, on the other hand, can promise direct delivery of the pollen from the male parts of one plant to the female parts of another. That's a good enough reason for many plants to invest in energetically expensive fruits or chemical compounds.

TYPES OF POLLINATOR

Generalist pollinators: These pollinate multiple species of plant, collecting nectar from many different flowers. Bees are our most famous generalist pollinators, whose services we rely on for the pollination of around one-third of the world's crops.

Specialist pollinators: These pollinate only one species of plant. They often have extreme adaptations, allowing them to retrieve nectar from a particular species. In most cases both insect and plant rely on each other for survival.

WEEVILS AND CYCADS

One of the earliest plant species that scientists believe insects to have pollinated is the tropical cycad, which was abundant in ancient Cretaceous forests 145-165 million years ago. These woody plants have separate male and female parts, which produce cones, similar to pinecones, once every year or so. During this reproductive period, the male cones swell and ripen, the temperature within them starts to rise and they begin to emit an unpleasant, yeasty smell. This attracts swarms of cycad weevils, which push their way between the scales of the cone and **feast on the soft flesh within**. As the cone's scales begin to separate, the cycad weevils mate and lay their eggs inside, rubbing themselves across the pollen-laden scales in the process. Once this is done, they leave in search of another cone.

Female cones are **similarly stinky**, and attracted cycad weevils push their way between their scales, hoping for a tasty meal. But the female's flesh is hard and bitter, so the weevil doesn't stay long. This doesn't matter, though, as they've already done their job of transferring the male cone's pollen to the female's ovules, effectively fertilising her.

DARWIN'S HYPOTHESIS

One of the first people to understand the link between plants and their pollinators was Charles Darwin in 1862. He spent a great deal of time studying orchids and noted that many orchid species had special and exclusive relationships with uniquely adapted insects. So certain was Darwin about the co-evolution of orchids with their specialist pollinators that when he discovered a Malagasy orchid (now named Darwin's orchid) with a 30cm-long tube leading to its nectar store, he predicted the existence of an insect with a 30cm-long tongue to exploit (and therefore pollinate) the plant. This species was later discovered and named Darwin's moth in his honour.

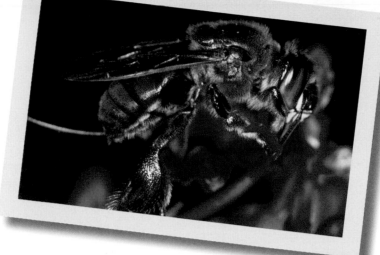

RETURNING GIFTS

Male orchid bees like to impress their partners with perfumes composed of scents from the various flowers they have visited. Luckily their favourite food plant, the bucket orchid, is obliging in supplying these aromatic oils – at a price. While the male orchid bee is stocking up on perfume, he must balance on the slimy edge of the bucket orchid's liquid-filled pitcher. Inevitably, at some point he falls in. It is then that he must repay the orchid for its gift of cologne. He scrabbles to the edge of the 'bucket' where, conveniently, evolution has provided a bee-shaped step, leading to a tunnel and safety. As the bee pushes up through this tunnel, the orchid contracts and grips hold of him, sticking a sac of pollen to his back. The tunnel remains contracted until the glue dries, at which point the bee is free to go. He escapes the tunnel, flies to another flower to add to his floral concoction and repeats the same process, except this time the orchid retrieves the pollen sacs from the bee's back and fertilises itself.

FALSE PROMISES

There are around 10,000 species of orchid that do not reward their pollinators with food. Instead they deceive insects into visiting them by displaying specific smells or sights. Some orchids give off only the smell of nectar without offering food, while other orchids favour sexual deception. One such example is the hammer orchid, which lures in male thynnid wasps by mimicking a female wasp in both appearance and smell.

The flightless female thynnid wasp spends almost all of her life underground, until she is ready to mate, at which point she emerges and ascends a blade of grass. Male thynnid wasps fly around in search of newly hatched females, hoping to pick one up, carry her to a food source and mate with her. If a male thynnid wasp tries to gather the dummy female of the hammer orchid, instead of flying off with a female, he is flipped over and rubbed against the orchid. This either covers him in pollen or removes pollen he has obtained from a previous encounter.

BLOODSUCKERS

Without blood flowing through our veins, transporting oxygen and food to all of our cells, we would die almost instantly. Rich in lipids and protein, blood is not only vital for life, it also makes an excellent food source. Some clever minibeasts have evolved to drain this precious fluid directly from the vessels of other animals and use it as their primary source of nutrition.

MOSQUITOES

Male mosquitoes are relatively benign, feeding predominantly on flower nectar. Females, in contrast, cannot produce eggs without consuming a mammalian blood meal. After locating a suitable host through a combination of chemical cues, she uses her long, pointed proboscis to pierce the skin, lubricating the incision with her anticoagulant saliva. It is this saliva that makes mosquito bites itch, as it causes the body to mount an immune response by releasing vast quantities of histamine. It is also through this saliva that viruses such as dengue and yellow fever are introduced into the host's blood. Mosquito-borne diseases are one of the leading causes of death in humans, resulting in millions of casualties worldwide every year.

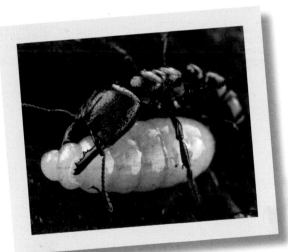

HUMAN DISEASES CAUSED BY BLOODSUCKING INSECTS

Mosquitoes carry yellow fever, malaria, dengue fever, Japanese encephalitis, West Nile virus, Zika virus, Chikungunya virus

Assassin bugs carry Chagas disease

Ticks carry tick-borne encephalitis, Lyme borreliosis (Lyme disease), typhus

Fleas carry plague

Tsetse flies carry African trypanosomiasis (sleeping sickness)

Sandflies carry leishmaniasis

DRACULA ANTS

Dracula ants drink the hemolymph (the ant equivalent of blood) of their own offspring! The soft skin of the larvae is pierced using the adult's sharp mandibles, causing hemolymph to flow out through the youngster's skin. The ritual is usually reserved for the queen, but if food is running low and the workers begin to starve, then they will suck hemolymph from the colony's young too!

MOSQUITO TERMINATOR

The vampire spider (*Evarcha culcivora*), feeds on mosquitoes, preferably females that have recently sucked up a meal of mammal blood. It is the only spider known to feed on blood and probably the only animal that chooses its prey because of their feeding preferences.

FLEAS

Fleas are the only group of insects known to feed solely on blood. There are over 2,000 different species of these tiny, wingless jumpers, and each has a preferred host from which it likes to drink. But most fleas are not fussy and will drink from any available mammal when they are desperate.

ACARI

Mites and ticks come from an enormous group of arachnids, called Acari. Mites are extremely diverse and are found all over the world, exploiting a vast array of habitats ranging from the insides of living animal bodies to compost heaps and deep ocean beds. Mites can also live on the skin, fur and feathers of our domestic pets, sucking blood and causing significant irritation. Ticks generally live on the outside of animal bodies and feed only on blood. Both mites and ticks are responsible for causing diseases to humans and our pets. Mites also have a significant effect on agriculture, causing serious disease in both plants and bees.

SPECIES PROFILE

IXODIDAE SPECIES

COMMON NAME Hard ticks

DISTRIBUTION Worldwide

SPECIAL SKILLS Attaches to a site where blood capillaries are very superficial, like a dog's ear. After a big blood meal, it can engorge up to 120 times its unfed weight.

VAMPIRE MOTHS

Unlike mosquitoes, in vampire moth species it is only the males that drink blood, including human blood. The male vampire moth uses its hollowed-out proboscis to pierce the skin of various animals – it is even strong enough to pierce the thick hide of buffalo, tapirs and elephants. It is thought that males adopted this behaviour to provide more attractive nuptial gifts to prospective mates.

HORSEFLIES

Like mosquitoes, it is only female horseflies that bite, requiring a blood meal to mature their eggs. However, horseflies are not nearly as neat about the process as mosquitos: horseflies use the dagger-like front portion of their mouthparts to saw and slash into their victim's skin until it bleeds. Once the blood is flowing, the other part of the mouth, which is sponge-like, is used to suck up the blood. As a result of the cutting action, Horsefly bites can be very painful and the victim often brushes off the horseflies after it bites. It therefore usually takes horseflies multiple attempts to obtain enough blood with which to mature their eggs.

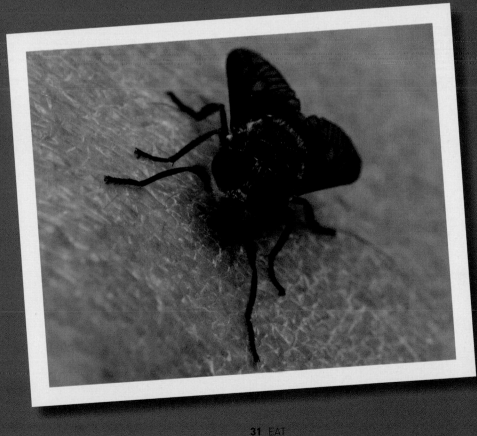

ASSASSIN BUGS

This is a large family of bugs within the Hemiptera order, which are easily recognisable by their curved hollow beaks, also known as 'rostrums'. True to their names, assassin bugs are slow, calm and deliberate. These bugs are often particular about their tastes and many of them specialise in eating one type of prey.

Ant wolf bugs are feathery insects that lie in wait on ant trails, oozing a chemical (called a pheromone) to attract ants. The ant wolf waits until an ant is close enough to taste the pheromone then it stabs it in the back of its head.

Millipede assassin bugs can feast on millipedes that are much larger than they are (right, top) by injecting their prey with saliva that contains a chemical that paralyses prey and digests it from the inside out.

Bee assassin bugs hide on flowers, waiting for pollinators to arrive in search of sweet nectar (right, bottom).

The **kissing bug**, which has a taste for human blood, gets its name from its habit of biting around its victim's mouth while he or she sleeps. It spreads disease by pooing close to the site of its bites.

Stealthiest of all the assassins, the **giraffe assassin bug** can even cross spider webs undetected. Waiting for a slight breeze to mask its movements, this assassin stretches the silk strands of the spider web, thread by thread, until they break. As each thread is broken, the assassin bug moves closer to the spider without creating any vibrations that would reveal its presence. It holds onto the torn ends of the threads and releases them gently to prevent any rapid recoil that would alert the spider to its presence. At last, when it is almost directly upon the spider, it strikes, grabbing its prey in its raptorial legs and driving its rostrum deep into the spider's body.

Like the giraffe assassin, the **spider assassin bug** also targets spiders. But rather than creeping up undetected, the spider assassin intentionally alerts the spider to its presence. Mimicking the movements of an insect trapped in a web, the spider assassin waits until the spider comes closer to investigate then when it's within striking distance, it attacks!

SPECIES PROFILE

ACANTHASPIS PETAX

COMMON NAME Ant assassin bug
DISTRIBUTION Africa, Malaysia, Philippines
SPECIAL SKILL After sucking the juices out of its ant victims, it wears the bodies as a coat (right) to evade detection by other ants.

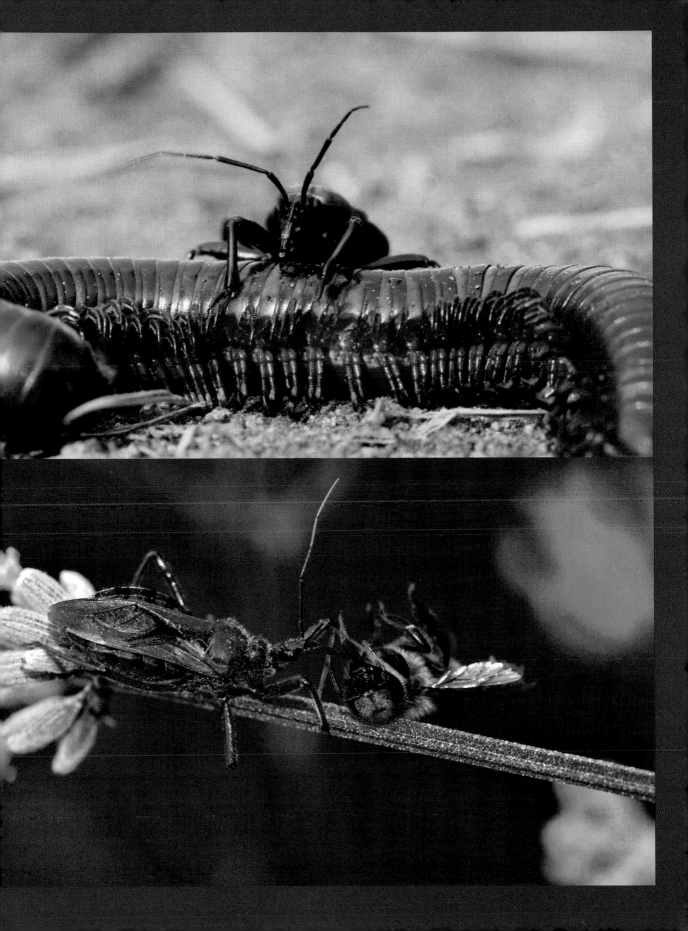

pREY

Predators are creatures that catch and kill other animals for food. The animals they eat are known as prey. Both predators and prey depend upon each other – without prey, predators would starve and die, while without predators, prey numbers could spiral out of control. The two populations are therefore interdependent – when there is more prey to eat, more predators survive, and vice versa. Over thousands of years, predators and prey have evolved adaptions to more effectively hunt and evade one another. As we learned on page 21, the development of these adaptations and counter-adaptations is known as an evolutionary arms race.

While many invertebrates feed solely on vegetation, huge numbers of minibeasts are predatory and survive exclusively on a diet of other minibeasts. In sheer volume, minibeast predators consume more flesh than all of their mammalian counterparts combined.

Despite their sometimes-diminutive size, once seen up close, these invertebrate predators are fearsome-looking creatures. In fact, most science-fiction aliens are based on predators from the invertebrate world!

ATTACK

Successful predation relies on four main steps: searching for prey, identifying prey, catching prey and killing or injuring prey. Adaptations at each of these steps have resulted in a huge variety of magnificent predators. From crushing jaws to powerful neurotoxins, and cloaks made of dead victims to slingshots made of silk, invertebrate predators demonstrate some of the cruellest and most fascinating methods of capture and assassination in the entire animal kingdom.

CHASE ME, CHASE ME

For some predators, it's all about the thrill of the chase. Whether it's running so fast they become temporarily blinded or performing lightning-fast aerobatics, minibeasts are among the fastest and most formidable predators on the planet. For other minibeasts, the speed at which they gather their prey is literally a matter of life and death.

DRAGONFLIES

The dragonfly is the ultimate aerial predator. With enormous eyes covering almost its entire head, and containing up to 30,000 individual facets, it has nearly 360-degree high-definition vision. Not only does this make it easy for the dragonfly to spot its prey initially, but it is also able to lock onto and track the movements of aerial targets. By moving its head and body independently, it can follow its prey with great precision, adjusting its own flight path to fall in line with that of its target. With incredible dexterity, the dragonfly can fly forwards, backwards, upside down, hover and turn on the head of a pin, all at speeds of up to 50km/h (31mph). Unlike lions, which pursue their prey across the savannah by mimicking their movements, the dragonfly can work out the flight pattern of its prey and track where their target will be at the exact moment they intercept it. This results in a near 95 per cent hunting success rate. When the moment of impact arrives, the dragonfly uses its pendulous hairy legs to encage its victim. It then incapacitates the prey by clamping down with its hinged and serrated jaws, which can open as wide as the dragonfly's whole head.

AMAZING FACT!

Dragonflies have even been known to snatch spiders out of their webs.

TIGER BEETLES

These beetles are among the fastest sprinters in the insect world, reaching speeds of up to 9km/h (5.5mph). That might not sound like much, but it actually means that tiger beetles travel 125 times their own body length every second! As they gallop along on their long and spindly legs, tiger beetles prevent themselves from falling over by rigidly holding out their antennae in front of their bodies. In pursuit of prey, the tiger beetle is only hindered by the ability of its brain to keep up with its legs: these speedy beetles run so fast that they cannot capture or process images of their prey quickly enough to give them a continuous image. This results in a staggered chase, consisting of short bursts of action. Yet despite needing to stop every now and again, tiger beetles are still very efficient hunters, descending on prey such as other beetles, grasshoppers and caterpillars with huge powerful jaws, and regurgitating digestive juices that begin to break down their meal before it even reaches their mouths.

JUMPING SPIDERS

These tiny spiders, with their friendly, cute faces, certainly do not look like efficient killing machines. But with powerful front legs and the ability to jump as much as 100 times their body length, Jumping spiders are fearsome predators. Their eight eyes, optimised for pursuit of fast-moving prey, provide them with excellent eyesight. The huge, forward-facing front eyes allow them to accurately judge distances, while the side-facing eyes detect the slightest of movements. Jumping spiders are constantly on the move, scanning their heads from side to side in search of food. Although it rarely misjudges, should the Jumping spider fall, it is protected by a safety line of strong silk.

SOLIFUGAE

The species in the Solifugae order are neither spiders nor scorpions, despite what their name suggests: they are known variously as camel spiders, sun spiders, wind spiders and wind scorpions.. They are arachnids in their own class, with eight legs, hairy bodies and no venom. Most species are nocturnal and live in the desert. While some Solifugae species will sit and wait for their prey, most prefer to chase them down. Solifugae are generalists, which means they will chase and consume insects, spiders, scorpions, small reptiles and sometimes other Solifugae! They are able to catch most prey they set out to chase, reaching speeds of up to 16km/h (10mph). Once it catches its victim, the solifugid wastes no time in **tearing it apart with its massive jaws**. These jaws can occupy up to one-third of the Solifugid's whole body and are armed with sharp spikes. Furthermore, the jaws split into four sections, which can all move independently, in both vertical and horizontal planes, which allows them to munch and crush prey – with audible crunch.

SAHARAN SILVER ANTS

For these beautiful Saharan silver ants, time is of the essence more than it is for any other creature. They have less than 10 minutes every day to leave the nest and forage. When temperatures are low, predatory lizards prowl the desert. When temperatures are high, they can exceed 100°C (212°F). After the predatory lizards retire, the ants have a small chink of time before their body temperatures exceed 53°C (127°F) to safely risk their forays into the desert. Using their long legs for speed and to lift their bodies away from the baking sand, they must locate their prey and bring it safely back to the nest with absolute efficiency.

FASTEST MINIBEASTS

Moth: Hawk-moths have been recorded at 19km/h (12mph).

Dragonfly: The southern giant darner's top speed is 22km/h (16mph).

Butterfly: Skippers can fly at up to 50 km/h (30mph).

Fly: Horseflies can fly at an astonishing 145km/h (90mph).

AMBUSH

Not all predators rely on speed to catch their prey. I know several domestic cats that are excellent hunters, yet remain several kilograms overweight. They simply do not work hard enough to burn off the extra pounds, because they have mastered the art of 'sit and wait'. If you're not in a rush and have time to kill, ambush is a fantastic way to save energy and still get a meal. These voracious ambush predators catch their food through a combination of stealth, patience and ferocity.

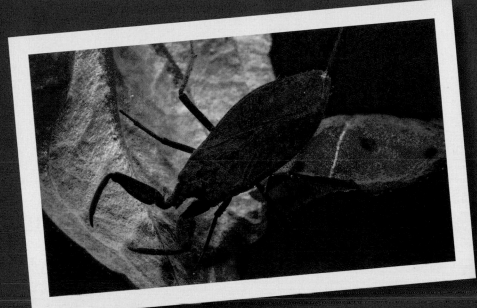

WATER SCORPION

The water scorpion (above) is the crocodile of the insect world, lying in wait in murky waters, often under dead leaves and other plant debris, for suitable prey to pass by. Not actually a scorpion but rather an insect in the bug family, the water scorpion owes its name to its enlarged front legs that have adapted to catch prey (known as raptorial legs). Although it has no gills (and therefore must breathe fresh air), the water scorpion can remain still underwater for long periods due to its modified tail. The tail consists of two long 'fronds' that act like snorkels, allowing the water scorpion to breathe underwater without fully surfacing. Water scorpions are clumsy swimmers but rarely move far, instead using their large eyes, which are adapted for underwater vision, to spot insects, fish and small amphibians that move within grabbing distance. As soon as potential prey is within its snatching zone, the water scorpion springs into action, reaching out and tightly clasping the creature. It then uses its sharp proboscis to inject **a cocktail of powerful neurotoxins** and digestive juices into the animal's hapless body. This both kills and prepares prey for eating at the same time. Once the potent cocktail has taken the desired effect, the water scorpion sucks up the insides, leaving only the shell. Water scorpions do not generally leave the water, but if the food supply in their pond dries up, they can crawl out and fly to a new one.

PRAYING MANTIS

Sitting in wait, perfectly camouflaged, the praying mantis can turn its head 180 degrees to check not only in front but also over each shoulder to see if any suitable prey appears nearby. While it waits, the mantis meticulously cleans its spine-edged raptorial front legs to ensure they are game-ready. It isn't fussy; anything small enough for those praying front legs to hold will do.

As soon as a potential victim is selected, the mantis aligns its entire body to the job in hand. Moving its head and body independently, it maintains its line of sight, its focus never broken. Ever so slowly, the mantis approaches its prey until it is within striking distance. **Without warning, the mantis strikes**, squeezing its prey's body in its legs, holding on tightly while tucking in with its powerful jaws. It often drops less nutritious bits of prey, like wings and legs, because it knows it won't be long before it strikes again and can feast on the most nutritious parts of the next carcass.

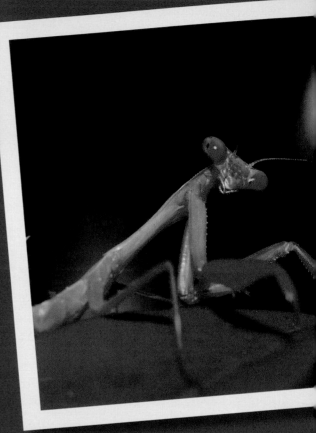

TIGER BEETLE LARVAE

While their parents are masters of speed, tiger beetle offspring, with their significantly shorter legs and grossly more cumbersome bodies, employ a different tact for catching their prey. The beetle grub lies in wait in its perfectly circular, vertical burrow, its flattened head neatly capping the entrance to its lair. Only the tips of two **ferocious-looking curved jaws** project above the surface. The tiger beetle larva spends the majority of its life in this position, waiting for an unsuspecting minibeast to scuttle within lunging distance so that it may strike, launching its powerful jaws deep into its flesh. Should the grub happen to attack larger, stronger prey than itself, it has a protective mechanism to prevent it from being wrenched from its burrow. A spiky humpback halfway down its body anchors it tightly into its hole.

FLOWER CRAB SPIDER

Flower crab spiders dine on the pollinators attracted to flowers, such as bees, flies and butterflies. They are often beautifully camouflaged, sitting invisibly in wait, front legs outstretched, waiting for a meal to drop by. They do not make webs but instead grab their victim directly and deliver a paralysing bite.

TRAPDOOR SPIDER

It is a common misconception that all trapdoor spiders create webs that are fronted by 'trapdoors'. In fact, the majority of trapdoor spider species do not have doors on their burrows but instead sit in the open entrances, feet slightly protruding in order to sense soil and airborne vibrations as their prey approaches. This method of prey detection is called mechanoreception. Some species take this one step further and construct trip lines, which send direct vibrations to their feet sitting atop the strands of silk. Once a vibration is detected and acted upon, the prey is rarely missed. But these spiders are very picky about which vibrations they react to, and they simply ignore the majority. However, once a prey item is within reach, the spider will dart forwards and grab it, rarely ever fully leaving its burrow.

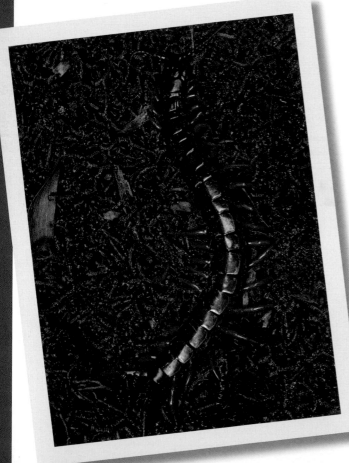

GIANT CENTIPEDES

These centipedes are undoubtedly one of the most frightening predators in the invertebrate world. Masters of both ambush and pursuit predation, with potent venom and a nasty attitude, they are not creatures to get on the wrong side of. Growing to lengths of up to 30cm (11in), these large centipedes dine not only on insects, millipedes and tarantulas but also birds, lizards, snakes and rodents. Add the ability to scale walls and premeditate attacks to this centipede's already remarkable list of talents and I think I've found my most feared minibeast.

AMAZING FACT!

There's a Venezuelan population of Amazonian giant centipedes that hang on the roof of a cave inhabited by bats and catch the bats in mid-flight as they leave.

VENOM

Venom and poison are not the same thing. While poisonous animals produce toxins that transfer only when touched or eaten, venomous animals deliver their poison with a stinger or via a bite. We will cover poisonous minibeasts later in the book, but for now let's concentrate on venomous species.

Scientists are particularly keen on determining how we can use animal venom in our own medicines, and have developed many different methods for analysing venom. Perhaps the most famous way of classifying venomous bites is the Schmidt sting pain index (shown on page 49), created in 1983 by US entomologist Justin O. Schmidt and since refined in order to grade the relative pain caused by different stings. Through the index, he graded his own experiences of being stung by a wide range of venomous invertebrates on a scale of 0–4, with 4+ being the most painful.

TYPES OF VENOM

Neurotoxic: Affects the nerves and nervous system.

Cytotoxic: Attacks and kills all living cells.

Myotoxic: Primarily affects muscle tissue.

Hemotoxic: Destroys red blood cells.

POISON v. VENOM

Poisonous: producing poisonous toxins as a means of attacking predators. Toxins are only transferred if the producer is touched or eaten.

Venomous: producing and capable of injecting venom using specialised apparatus such as a stinger or fangs.

BULLET ANT

This infamous Amazonian bullet ant (above) is thought to have the most painful sting known to man. It receives the highest grade possible on Schmidt's sting pain index (see page 49). In some venomous species, the aim of the sting is to cause instantaneous pain to make its predator release it. Not so with bullet ant venom, which causes **waves of throbbing agony** that can last for up to 24 hours. At nearly 3cm (1in) long, the bullet ant's excruciating sting is not the only thing you need to be careful of when coming into contact with this minibeast – it also has enormous jaws that can deliver a serious bite. Bullet ants nest in the ground but walk up to the canopy to forage, so there is a good chance you could see one scaling a tree trunk – if you happen to be walking through the forests of the Amazon basin.

SCORPION

All 1,500 or so species of scorpion that we currently know of have venom in their stingers. The potency of their stings is widely variable, though, with only around 25 species known to be deadly to humans. Even for the deadliest of species, stinging is usually a last resort, as it takes a week or more to generate a new venom supply. As a general rule of thumb, if the scorpion has big pincers and a thin tail, its venom is probably weak and it is more likely to attack you from the front. However, if the scorpion has small pincers and a fat tail, it is likely to be quicker with its sting. It is probably no surprise, then, that the scorpion with the thickest tail of all, the fattail scorpion, is considered to be the most dangerous of all scorpions. It can even flick venom out of its stinger into the eyes of potential predators.

AMAZING FACT!

The scientific name for the scorpion's stinger is the telson. It contains two venom glands as well as a a curved end that narrows into a sharp needle-like tip for delivering its sting.

SPIDERS

Delivering their venom through hinged, curved fangs, spiders primarily use venom for the quick immobilisation of prey. The more dangerous and feisty the prey, the stronger and faster-acting the venom needs to be. Hunting spiders generally have more potent venom than those that spin webs, but all species of spider – except those in the Uloborid family (cribellate orb-weavers) – have venom of some description.

Spiders rarely use their venom in self-defence, generally preferring to run away than to stay and fight. Nonetheless, a cornered spider will protect itself, and some spider species pack quite a venomous punch. Most powerful of all the spider toxins is that carried by the Brazilian wandering spider, which can cause death through paralysis of the breathing muscles.

CENTIPEDES

Venom claws were first documented in centipede ancestors over 400 million years ago, suggesting that centipedes were one of the first creatures to develop and use venom. More correctly known as forcipules, the venom claws are modified legs, which are needle-like, hollow and contain pear-shaped venom glands. The pain generated by the bite is generally proportional to the size of the centipede. Smaller species barely break human skin, while large species, such as *Scolopendra* (Giant centipedes), can cause extreme pain that can last for days.

SCHMIDT STING PAIN INDEX

Stings of the sweat bee, fire ant (left) and bullhorn acacia ant.

"Sharp, sudden, mildly alarming. "
– Justin O. Schmidt

1

Stings of the bald-faced hornet (left), yellow jacket wasp and honey bee.

"Rich, hearty, slightly crunchy."
– Justin O. Schmidt

2

Stings of the paper wasp (left) and red harvester ant.

"Bold and unrelenting."
– Justin O. Schmidt

3

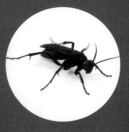

Sting of the tarantula hawk (left).

"Blinding, fierce, shockingly electric."
– Justin O. Schmidt

4

Sting of the bullet ant (left).

"Pure, intense, brilliant pain."
– Justin O. Schmidt

4+

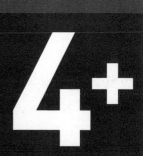

CONE SNAIL

The predatory cone snail, like all snails, is a slow-moving creature. Its venom must therefore be potent and fast-acting in order to paralyse its prey almost instantly. It delivers its venom, which contains a cocktail of more than 100 different toxins, via a harpoon-like proboscis. The barbed harpoon can extend to twice the length of the cone snail's body and its venom can immobilise fast-moving fish and even humans. The harpoon remains embedded in the fish until the fish becomes stiff and immobile, at which point the snail draws the fish back to its mouth to eat it.

AMAZING FACT!

Scientists are starting to extract and use animal venoms in human medicine. So far, venom has been used for detecting and treating cancer, creating immunotherapy vaccines, developing new painkillers and even in the treatment of erectile dysfunction.

SPECIES PROFILE

CLASS CUBOZOA

Common name: Box jellyfish

Distribution: Tropical and subtropical oceans

Special skill: Widely considered to be the world's most venomous animal containing toxins that attack the heart, nervous system and skin cells.

SUPER SILK

Spider silk is one of the toughest materials on the planet. Five times as strong as steel yet elastic and flexible, this sturdy fibre is an exquisite cocktail of crystals and protein. Secreted from silk glands as a liquid, silk hardens irreversibly in the spider's spinnerets – the ducts out of which the silk exits the spider's body. Not all silk is the same: it is usually white but there are also gold, blue-green and pink variations. Some species of spider can produce up to seven different types of silk.

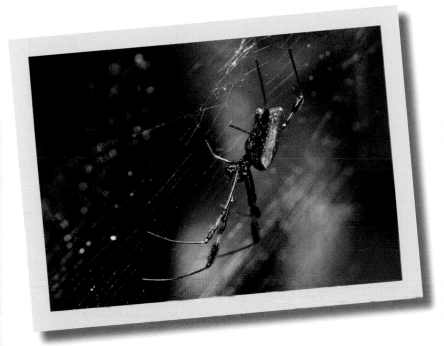

ORB-WEAVER

When asked to picture a spider web, the image we conjure up is inevitably the orb web, a wheel of spokes connected by concentric spirals of silk. These range from the tiny (less than 10cm/4in) to the enormous (more than 1m/3ft in diameter). The spiders constructing these webs usually have poor eyesight, so they rely on the vibrations created by prey being caught in the web to detect their next meal. The golden orb-weaver spider (left) constructs the most enormous and beautiful of these orb webs.

CONSTRICTOR

Unlike most other families of spider, uloborids – cribellate orb-weavers – do not have any venom. Much like boa constrictors and pythons, these spiders are constrictors. Instead of using their bodies, they **crush their victims to death** using vast quantities of strong silk, sometimes spending over an hour wrapping them up. This wrapping process compacts and buckles the prey's body beyond recognition. Once dinner is imprisoned in the silk body bag, the spider regurgitates digestive juices onto it, then sucks up the fluids from inside, leaving a hollow silk shell.

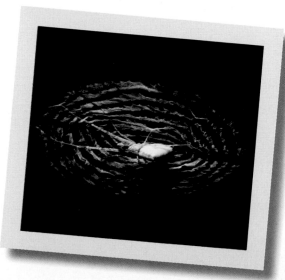

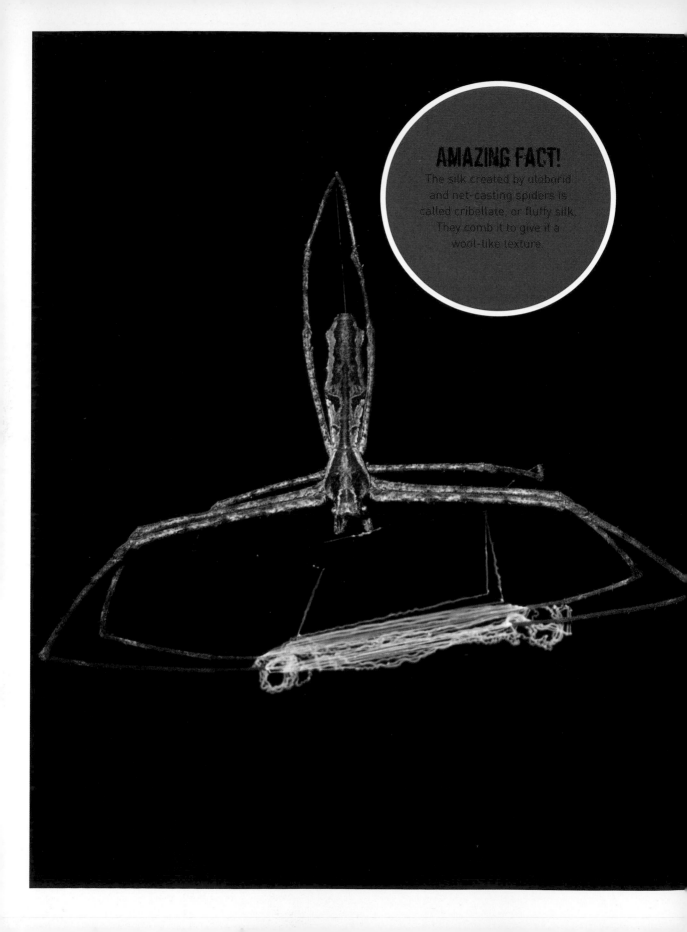

BOLAS THROWER

Bolas spiders are tiny spiders that don't use their silk to build webs. Instead they dangle on a single horizontal trapeze line, saving precious silk for the construction of their weapon of choice: the bolas (a sticky globule, apparently named after a South American throwing weapon). The bolas itself is also held on a single thread, hanging from one of the spider's front legs and ending in **an extraordinarily sticky globule of silk**.

Although the bolas is very effective at ensnaring any potential prey that it hits, its range is very small. Prey must come very close to the waiting spider in order to be captured. To attract its food of choice, male moths, the bolas spider emits female moth sex pheromones. The male moth approaches, fluttering slowly and clumsily, antennae extended, in pursuit of what he expects to be a prime mating opportunity. The bolas spider has lightning reactions: as soon as the male moth is within range, it uses its front leg to fling the bolas at the oncoming moth, then reel it in once it is captured. After a successful hit, the spider eats both the prey and the bolas, then sets about pulling more silk from its spinnerets in order to repeat the whole process.

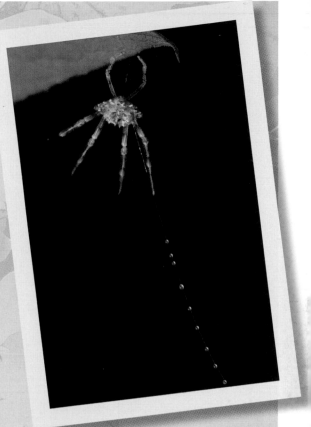

NET-CASTER

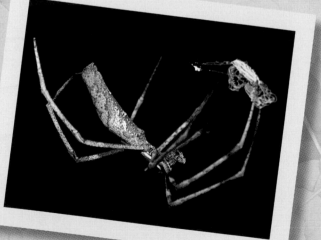

Stick-like and camouflaged during the day, the net-casting spider hunts under the cover of darkness. Its hunting technique therefore relies heavily on its huge eyes and excellent vision in low-level light. At night, the net-casting spider takes up its position, hanging from a loose scaffold web, often just above the forest floor where nocturnal insects are likely to pass. Before potential prey crosses its path, the net-casting spider may stretch its front legs down to the floor or drop white marker faeces to further improve its accuracy once it strikes. Once it has judged the distance, the spider pulls its thick, stretchy silk wide between its four front legs, building up the elastic energy stored within the fibres. Then it lies in wait until an insect walks or flies past. As soon as the spider spots the prey, it stretches the net even further – up to three times its resting size – then lunges onto its prey and releases the silk, entangling its victim within the threads. **The prey is rapidly bitten, paralysed, wrapped and then eaten**.

CATAPULT ATTACK

The slingshot spider's web looks much like the webs created by any other orb-weaver, except for one important difference. The web is attached at the centre to a nearby twig or stalk via a dragline (a long, thin line of silk that acts as a safety line). This pulls the web into an energy-loaded cone. When a midge or other small insect flies near the web, the spider activates the slingshot mechanism, firing both itself and its web towards its prey, greatly increasing the velocity of impact. This method is thought to be particularly effective in ensnaring species whose flight is slow or erratic, such as mosquitoes, which may not ordinarily be trapped by silk.

HOW DO SPIDERS USE SILK?

Sensing vibrations: Spiders know when insects fly into their webs because they feel vibrations along the silk spokes of their webs.

Wrapping prey: Many spiders wrap their prey in silk, either to immobilise them or to store them for later.

Lining burrows: Some spiders, particularly tarantulas, live in silk-lined burrows.

Constructing trapdoors: Those trapdoor spiders that make doors (see page 44) construct them from silk – even the hinges are made of silk!

Safety lines: Many spiders constantly produce draglines as they move around. Some species use them to swing or climb to safety.

Ballooning: Some spiders use their silk for dispersal via air currents.

Courtship: Some species cover their draglines in pheromones to attract mates. Others pluck their partner's webs to tell them they are mates, not food.

Mating: In some species, male spiders tie up females with their silk, while other males make sperm webs to transfer their sperm to females (to avoid getting eaten, as some females cannabalise males after mating).

Egg sacs: Some spiders use silk to protect their eggs.

WEB OF DECEIT

Ingenious as spiders are in their use of silk and predation upon other species, they have many predators of their own. Birds, lizards and mammals such as monkeys pluck spiders straight out of their webs. For smaller predators, spiders on their webs still make appealing sitting ducks. It just takes a little more cunning and a lot more stealth to catch them.

WEB THIEVES

Why catch prey yourself when you can steal your dinner from someone who has already trapped it? Scorpionflies specialise in removing prey items from spider webs, dissolving the spider silk by regurgitating brown liquid all over it. However, it is a risky business, often resulting in the scorpionfly becoming dinner for the very spider it was trying to steal from.

WEB INVADERS

Dewdrop spiders are also web thieves. They are quite capable of spinning their own webs but prefer to invade and squat on the edges of other, larger spider webs and feed on tiny insects trapped there. In many cases they are tolerated, as small prey is of no interest to the host spider. This dewdrop spider has lucked out and is feeding on a lizard's tail while the banana spider above it tucks in to the rest of it.

PRETENDING TO BE PREY

Pirate spiders like the one below pluck at the threads of orb webs, causing them to vibrate as if an insect is trapped. The orb spider (top) rushes over, expecting to find its next meal, but instead is bitten on the leg by the waiting pirate spider. Luckily for the pirate, its spider-specific venom works almost instantly, preventing retaliation.

SMART JUMPERS

Like all jumping spiders (see page 38), portia spiders are excellent jumpers with superb eyesight. But even by jumping-spider standards, portias are pretty exceptional. They are able to calculate three-dimensional jumping trajectories and take into account wind, speed and distance. They can also remember the position of their prey even when it is out of sight. Spider-hunting portias have rightly gained the reputation of being the most intelligent spider out there. Adaptable and resourceful, portias (like the one on top of the nest above) use different techniques for catching different spider species: they approach spitting spiders from behind to avoid becoming trapped in their glue; lower themselves into the blind spot of web weavers to attack from the air; and lure orb-weavers towards them by plucking on their webs.

TRAPS

Webs may be the best-known minibeast-trapping device, but as we've seen, spiders use several ways to ensnare prey from chasing and ambushing to using silk nets and webs. Many other invertebrates have equally effective methods of catching their prey. With bright lights to lure their victims and poisoned glue to subdue them, these minibeasts give spiders a run for their money in the ultimate deathtrap stakes.

DEADLY SANDPIT

Antlion larvae dig crater-shaped pits in soft sand, then bury themselves in the centre. They become all but invisible, with only their jaws left exposed. As ants and other small insects scuttle by, they inevitably fall into the pit and tumble down its steep walls. The loose sand makes it difficult to escape, and this is compounded by the antlion's tendency to flick sand at any insect that tries to escape its deathtrap. Eventually, the trapped prey will wobble too close to the antlion's open jaws and to its demise.

AMAZING FACT!

CAVE MUCUS

New Zealand glow-worms, also known as New Zealand fungus gnat larvae, live in dark and dank places – usually caves – where there is no wind or light and a still body of stagnant water nearby. They lie in **hammocks of mucus**, slung from the ceiling of the caves, their abdomens glowing brilliant blue due to a chemical reaction involving oxygen and a chemical called luciferin. This light attracts midges, which hatch from the water below and fly to investigate the luminous ceiling. Sadly for the midges, this is exactly what the glow-worms want them to do. Hanging from each glow-worm's hammock is a cluster of silk snares, covered in beads of sticky mucus. The midges become entangled in the sticky fishing lines, sending vibrations up to the glow-worms, which haul the threads up and feast on their catch.

SLIMESHOOTER

This rainforest-dwelling worm (right) looks velvety and soft to the touch, but its cute exterior is deceiving. When the velvet worm encounters potential prey, it rears up the front of its body and **sprays two jets of slime** from modified legs on its head. These gluey streams of mucus don't fall accurately, but they cover a large area, reaching distances of up to 30cm (20in) and hardening within a matter of seconds, enmeshing and paralysing the velvet worm's prey.

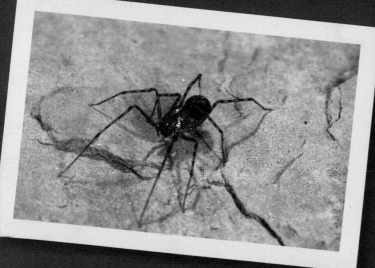

SPITTING SPIDER

The slow, nocturnal spitting spider (left) also binds its prey into immobility with congealed, sticky spit. The spit actually comes from its venom glands and contains both venom and liquid silk.

DEFENCE

Each prey population develops its own strategies to evade the attack and capture of predators. Sometimes this comes in the form of a warning – for example, the presence of distinct markings or specific colours. In other cases, a prey minibeast takes a more direct approach, by running from or fighting its attacker. The most formidable predators of the minibeast world have exerted great pressure on their would-be invertebrate victims, which has led to the evolution of some serious prey superpowers.

PROJECTILES

Humans have used chemical weapons in both attack and defence for millennia, originally in the form of poisoned arrows and spears. In 1899, the use of poison or poisoned weapons was forbidden in warfare, yet hundreds of thousands of tons of poisonous gases were employed throughout the First World War, causing unprecedented death and injury. Now frowned upon in human society, chemical projectiles are still an extremely common form of defence in the minibeast world.

VINEGAROON

When threatened, uropygids – commonly known as vinegaroons or whip scorpions – can spray their attackers with a vinegar-like substance composed mainly of acetic acid. This spray can penetrate the exoskeleton of invertebrate predators and **blister the mouth and skin** of vertebrates. The vinegaroon can spray the fine droplets up to distances of 80cm (31in) and use its tail (pygidium) to aim with relative precision. If the predator is in front of the vinegaroon, it can raise the pygidium scorpion-like, right up over its head.

BOMBARDIER BEETLE

By detonating explosions using chemicals stored inside their bodies, bombardier beetles can fire **boiling hot toxic jets** at their attackers. The chemical compounds required for the detonation are stored separately inside the beetle's body and only allowed to combine when expelled at force from its abdomen. The jet can be directed with frightening accuracy, not only directly behind the beetle but also over its head or between its legs.

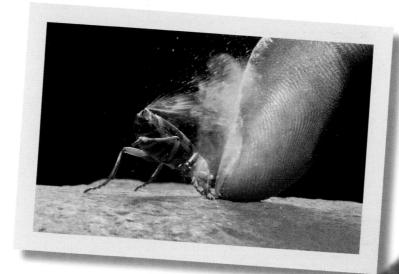

TARANTULA

Some species of New World tarantula have the ability to fire their body hair at predators. These quick-release missiles are called urticating hairs. The tarantula kicks the barbed projectiles to release them from its body, sending a bristly cloud flying towards its attacker. The hairs embed in the predator's eyes, nose, mouth and skin, causing itching and swelling, which can sometimes be fatal. At the very least, it buys the tarantula enough time to make a speedy exit.

TWO-STRIPED WALKING STICK INSECT

This conspicuous American stick insect has no reason to fear being detected even when it's on its clashing green food plant. When disturbed, the two-striped walking stick insect **sprays a caustic chemical** from small glands at the back of its head, which can temporarily blind or injure potential predators.

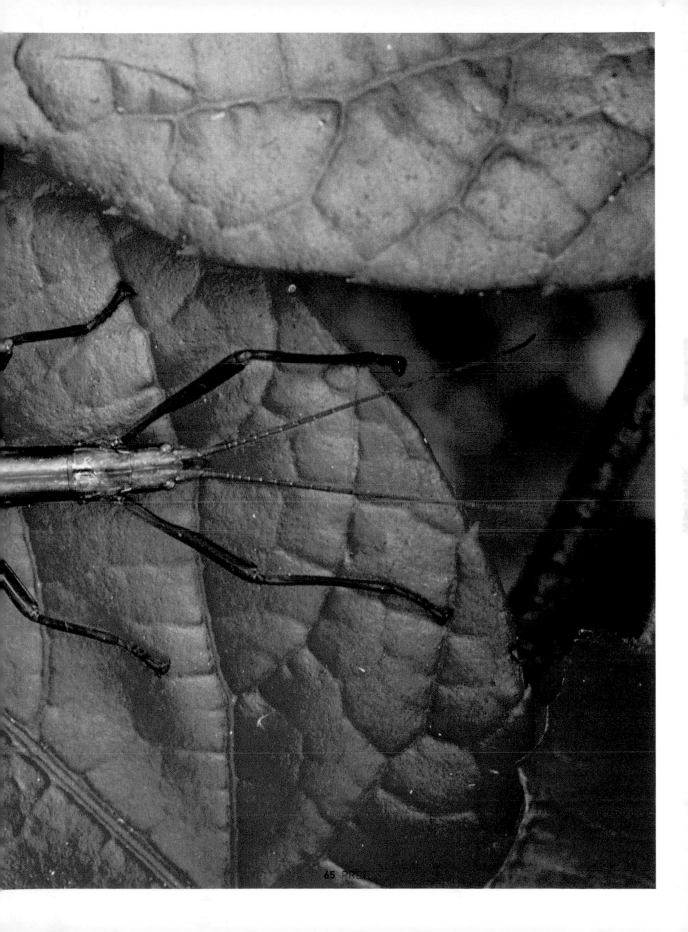

PLANTHOPPERS

Most minibeasts spray their projectiles directly at predators trying to attack them, but some planthoppers take a slightly different approach. They have evolved symbiotic relationships (see page 23) with certain species of gecko. The gecko approaches the planthopper, bobbing its head in what looks like a courtship display. In response, the planthopper flicks the gecko a drop of delicious honeydew. In return for these sweet treats, the geckos are thought to defend the planthopper from other predators.

CAMOUFLAGE

Camouflage is the art of blending into the background, or hiding in plain sight. Some species use their camouflage to become invisible to predators, others to lie secretly in wait for their prey. For some species, camouflage allows them to hide from both predator and prey.

EARLY THORN MOTH CATERPILLAR

In the daytime, this caterpillar looks and acts like a twig holding itself at just the right angle to match the foliage around it. At night, these caterpillars drop their masquerade and head off in search of food. Like the European lappet moth (below), adult early thorn moths also resemble leaves.

TYPES OF CAMOUFLAGE

Cryptic colouration: The species features the same colours as the background in which it lives.

Disruptive colouring: The species has a pattern, such as spots or stripes, which breaks up its outline, making it difficult to see.

Masquerade/mimesis: The species looks like an innocuous object, such as a leaf or branch, to avoid detection.

LAPPET MOTH

The resting position of the lappet moth (above), with its hind wings almost flat on the ground, produces an outline that suggests of a pile of dead leaves.

BIRD-DROPPING MINIBEASTS

Nothing looks less appealing than fresh bird poo – which works in favour of the appropriately named bird-dropping spider (main image) and this giant swallowtail caterpillar (right).

MARVELLOUS MIMICS

While some minibeasts try to become invisible, others choose not to hide from predators but to fool them into thinking they are something else altogether. This method of predator avoidance is also known as mimicry – when one species impersonates another.

DEFENSIVE MIMICRY is when one species pretends to be another to escape predation.
AGGRESSIVE MIMICRY is when one species pretends to be another to appear harmless or attractive to prey.

HORNET MOTH

The same size, shape and colour as a hornet, all the hornet moth (left) lacks in its disguise is the narrow hornet waist (below). It even copies the hornet's mannerisms and flight pattern.

TYPES OF DEFENSIVE MIMICRY

Batesian mimicry: A harmless mimic pretends to be a harmful one.

Müllerian mimicry: Where two species, both harmful, mimic each other's warning signals.

DEAD LEAF MANTIS

As its name implies, the dead leaf mantis is superbly camouflaged among dead, brown foliage. Their colouring ranges from dark brown to light brown. The front part of their thorax looks ripped and crumpled like a leaf. And when threatened, the mantis will freeze and throw itself to the ground with legs folded to look like a dead leaf.

DEFINITION

Thanatosis The act of pretending to be dead. Many insects use this trick to deceive predators. Some will even fall off high branches to the ground far below.

INDIAN ROSE MANTIS

The Indian rose mantis (right) is a specialist at swaying, in order to disguise itself as a stick blowing in the wind. The body of an adult resembles a violin, hence its other name, wandering violin mantis.

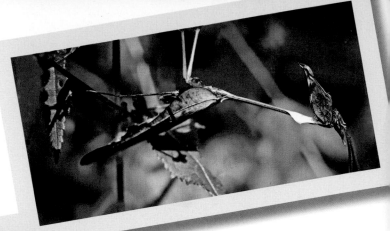

LEAF INSECTS AND KATYDIDS

Leaf insects (top left) and katydids (lower left) are often indistinguishable among living leaves. Some even sway in the wind to mimic the movement of leaves in a breeze. A katydid's whole body is moulded into a flattened leaf shape, complete with a central rib and 'damage' dot.

STICK INSECTS

Stick insects (right) and horse-head grasshoppers look just like twigs and can reach remarkable lengths – the longest being nearly 60cm (24in)! When frightened, many stick insects draw their legs into their bodies and fall, stick-like to the ground.

LICHEN HUNTSMAN SPIDER

Not only does the cryptic colouring of the lichen huntsman spider (left) perfectly mimic the trees on which it hides, but long hairs also break up its outline so its position is not even betrayed by shadows.

MOUHOT'S ROLLED LEAF SPIDER

When Mouhot's rolled leaf spiders (right) tuck in their legs and dangle from their webs, they can easily be mistaken for dead leaves.

ORCHID MANTIS

Sometimes, mimics are even more successful than the species they impersonate. Orchid mantises roughly resemble flowers, but they are often found sitting on leaves, rather than camouflaged on petals – for a good reason! Scientists investigating mimicry in these mantids found that pollinators were even more attracted to the colouring of the orchid mantis than they were to nearby flowers!

KERENGGA ANT-LIKE JUMPING SPIDER

The disguise of the kerengga ant-like jumping spider (below left) has double benefits. By mimicking the highly aggressive and territorial weaver ant (below right), the spider deters would-be predators that have previous experience of the weaver ants' aggressive swarming defence. But the disguise also allows the spider to pass freely through the ant colony, occasionally stealing ant larvae directly from the jaws of ant workers. The workers assume the spider is just another worker pulling its weight, but in fact the ant larvae becomes spider dinner. Even the male spider's immense fighting jaws are incorporated into their disguise.

ANT-MIMICKING TREEHOPPER

This treehopper appears to have an ant stuck backwards on its head, like some sort of bizarre helmet. In fact, it is an extreme form of mimicry, in which a whole new appendage has been created, rather than the modification of an existing part of anatomy. The particular type of ant that this treehopper mimics moves backwards when in it is in defensive mode. Thus, whenever the treehopper moves forwards it looks like an ant ready to attack.

SWALLOWTAILS

There are multiple species of butterfly that taste nasty or are even poisonous to predators, such as the pipevine swallowtail (above left). Most of these toxic species have non-poisonous mimics, in this case the pipevine's close cousin – the spicebush swallowtail (above right).

THE TIGER COMPLEX

In South America, a group of around 200 different species of butterfly are patterned in tiger-like stripes of black and orange. This form of patterning is known as the tiger complex. Some of these species are toxic, while others are merely pretending to be so. Either way, once a bird tucks into one toxic member of the group, it will apply that horrible experience to all the other butterflies and avoid them at all costs.

SNAKE MIMIC HAWK-MOTH CATERPILLAR

The snake mimic hawk-moth caterpillar does a fantastic job of not only looking like a snake but acting like one too. When threatened, it throws itself backwards off its branch and inflates its head, until two large snake eyes and a diamond-shaped head appear. If the predator continues to approach, the caterpillar can even pretend to strike, despite having no fangs or venom.

EYESPOTS

Eyespots are thought to have two functions. First, as predators often strike at their prey's head first (thus incapacitating them immediately), eyespots act as a false target. Predators are therefore directed towards less vital body parts and prey is given an opportunity to escape relatively unharmed, after what the predator expects to be a fatal blow. Second, eyespots can make prey seem bigger, more frightening or inedible to its predator. Examples of this type of camouflage include: (a) the European emperor moth, (b) the European eyed hawk-moth, (c) the peacock katydid, (d) the owl butterfly and (e) the peacock mantis.

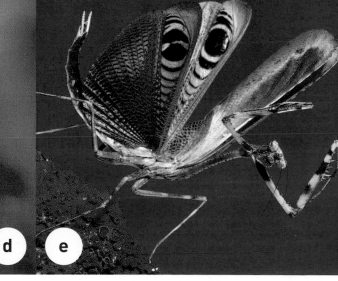

COLOUR ME TOXIC

Bright colours, such as red, yellow, black and orange, and bold patterns – for example, spots and stripes – are widely accepted as warnings across the animal kingdom. In most cases, conspicuous coloration is an honest signal and predators know through both instinct and experience that it is better to avoid interactions with such creatures. Sometimes, however, insects exploit the benefits such coloration gives them, without really being poisonous at all.

LADYBIRDS

These small familiar beetles carry poisonous alkaloids in their blood, which they secrete from leg joints when they are frightened. This **bitter blood** is bright yellow and has a distinctive smell, which is most obvious around groups of ladybirds that are clustered in their hibernation spots.

DEFINITION

Aposematism: the use of bright colours to advertise that a creature is poisonous or tastes bad.

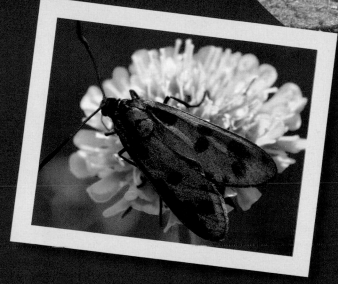

SIX-SPOT BURNET MOTH

SPURGE HAWK-MOTH CATERPILLAR

The spurge hawk-moth caterpillar's striking warning colours and patterning leave predators in no doubt about their toxic nature, which derives from their diet of leafy spurge – a noxious weed.

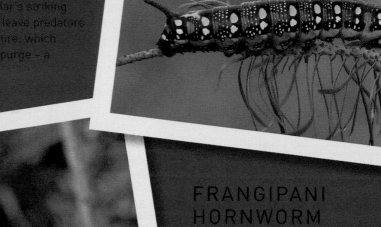

FRANGIPANI HORNWORM

Some people think that the warning coloration of the frangipani hornworm is supposed to make it look like a coral snake. Either way, those black and yellow stripes are a sure signal for a predator to **approach with caution**.

MADAGASCAN FIRE MILLIPEDE

Like many species of millipede, the Madagascan fire millipede can ooze toxins through holes along the side of its body when it is frightened. The substances secreted by some species can burn through the exoskeleton of insect predators, and irritate the eyes and skin of larger ones.

ESCAPE ARTISTS

When a situation is frightening, dangerous or unpleasant, it is natural to look for a way to escape it. To some people, escape comes naturally – escape artist Harry Houdini (1874–1926) built his whole career on his ability to get out of seemingly impossible situations. Minibeasts are no different and some of them go to extraordinary extremes to get away from predators.

FROGHOPPER

At only 6mm (¼ in) long, with relatively short back legs, the froghopper seems an unlikely contender for high-jump champion of the insect world. But despite appearances, froghoppers can jump higher than any other animal, relative to their body size – even higher than fleas! The key to their jumping prowess lies in their anatomy. Two huge muscles in the froghopper's chest, which compose 11 per cent of its entire body muscle mass, are used for storing energy and powering the back legs. Between jumps, these muscles act like **coiled springs** storing energy. Moments before a jump is required, the froghopper crouches, locking and tensing its enormous muscles. When the power building up in the back legs overcomes the locking system, the froghopper is catapulted to safety, accelerating at 4m/second (13ft/s). This creates G-forces that are 400 times as strong as gravity and 80 times those experienced by an astronaut blasting into space. It's an even more incredible feat when you consider that humans usually pass out at around 5 Gs.

GRASSHOPPER

Built for jumping, grasshoppers' enormous muscles power their huge back legs, allowing them to leap over 20 body lengths. The mechanism grasshoppers use for jumping is very similar to that used by froghoppers: they catapult themselves using the elastic energy stored in their muscles. They also have another trick up their sleeves: if a simple hop is not enough to carry them to safety, they can use their wings to fly away.

HARVESTMAN

Demonstrating a self-defence mechanism common to many invertebrates, harvestmen have the ability to voluntarily drop off body parts to distract predators. Much like some species of lizard can detach their tails when they are attacked, harvestmen can discard a leg, giving them time to escape and leaving something to keep the predator occupied. This behaviour is called autotomy. Although losing a body part may seem like quite a sacrifice, it's usually worth it, as it often saves the prey's life.

DRAGONFLY LARVAE

These larvae are voracious predators, feeding on other minibeasts, tadpoles and even small fish. But even these aggressive larvae have predators of their own. When dragonfly larvae feel threatened, they use jet propulsion to speed away by rapidly ejecting a stream of water out of their anus.

BRUTE FORCE

In ancient Rome, strength and fighting prowess were proven in amphitheatres. Gladiators were pitted against one another, kitted out in varying arrays of weaponry and protective clothing. Only the strongest would survive. Minibeasts face a similar fight for survival in the vast amphitheatre of the natural world. Luckily they have an impressive armoury to assist in their battles.

AMAZING FACT!

Having a hard skeleton, called an exoskeleton, on the outside stops insects from getting bigger. To grow they must break out of their old exoskeleton and grow a new one underneath! This process is called shedding or moulting (the scientific name is ecdysis).

BEETLES

The hard exoskeletons of beetles do a fantastic job of protecting their delicate insides. Exoskeletons are made of chitin, a fibrous substance like a stronger version of keratin. This thick, tough shell also protects the beetle's fragile wings and prevents the beetle from drying out when it is hot.

SOLDIER ANTS

As we already learned (on page 16), in ant colonies, the workload is spread evenly and every ant is given a role. In some species of ant, the different roles come with different body shapes. In these species, the role of protecting the colony is given to the soldier ants, which are usually bigger than the other workers and have enormous jaws.

JUNGLE NYMPH STICK INSECT

The female jungle nymph is a heavyweight of the stick insect world. Weighing more than 60g (2oz) and measuring more than 15cm (6in) long she is a contender for the heaviest insect. Although her bright green colouring is a remarkable camouflage, such a cumbersome body can be difficult to hide. If she is spotted, she first lets out a **menacing hiss** by vibrating her small pink wings. If the predator continues its attack, she lifts her tail and back legs scorpion-like over her head. Both her legs and the underside of her abdomen are covered in sharp spines. If the attacker still doesn't back down, the jungle nymph will snap her legs together, scraping her barbed back legs against the predator's face.

LONGHORN BEETLE

This beetle has a backup to its spiky defence. If approached by a predator, it whips its long antennae, which are lined with forward spines, back and forth. If the spines make contact with the soft skin of an attacker, the beetle then presses them back, allowing them to **dig deeper into the predator's flesh**.

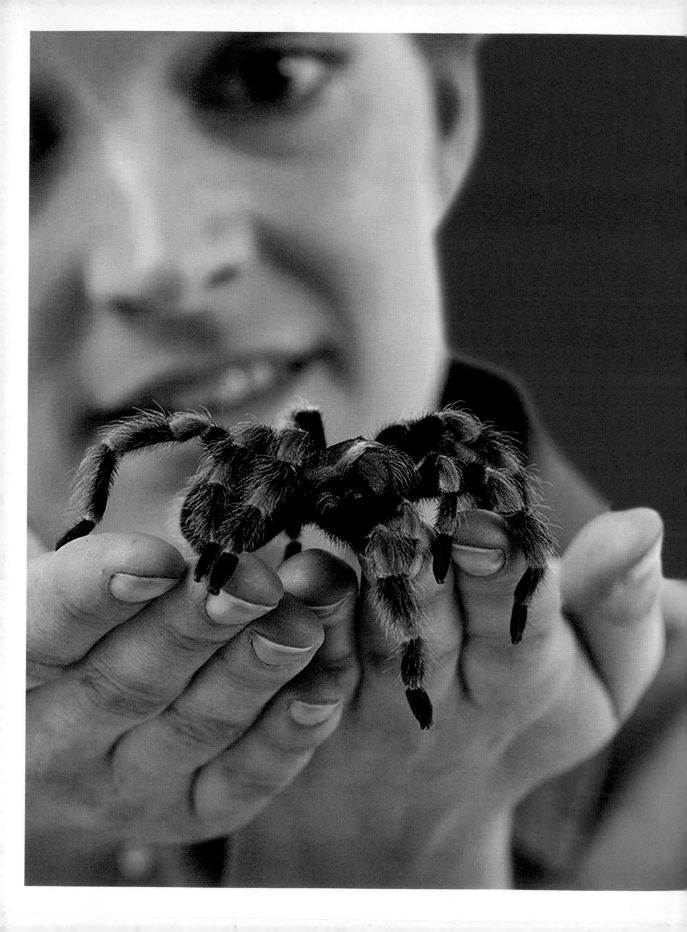

LOVE

Obtaining sufficient energy from food and evading death by predation are crucial steps along a minibeast's journey to adulthood. Once these goals are attained, passing on genetic information to the next generation becomes the minibeast's focus. Some minibeasts are capable of transferring their genetic material without mating, in a process known as parthenogenesis. But for most, the production of viable offspring is dependent upon the mating of a male and female.

For all species, courtship can be a tricky business. First, an invertebrate must correctly identify an appropriate specimen of the opposite sex – not such an easy task when you consider that plants often mimic female insects to deceive males into pollinating them. Second, the potential mate must be courted and seduced. Minibeasts, therefore, use a wide range of techniques to attract their lovers, including perfumes, serenades, dances and slimy cuddles. Finally, the act of mating must occur – and the male must make sure that only his sperm fertilises the female's egg.

After a successful mating, invertebrates need to ensure the safe emergence of their offspring. In this section we'll find out why some invertebrates simply leave their eggs to fend for themselves, while other species go to great lengths to care for their young, providing food, shelter and protection from predators.

If you thought the birds and the bees were fascinating, wait until you hear about the bedbugs and the bean weevils.

COURTSHIP

For most living creatures on earth, the primary goal of sexually mature individuals is to produce viable offspring. For some species, such as those that reproduce asexually and therefore don't need to coordinate with another individual, this is a relatively simple affair. For others, it requires persistence, skill and sometimes compliance with a carefully orchestrated sequence of events. From singing the right notes to stepping the right steps, courtship is a tough and competitive game, designed to ensure that only the best genes make their way into the DNA of the next generation.

CHOOSING A MATE

For a human male, the main aim of courtship is convincing a female to mate with him rather than all the other males vying for her attention. Groups of human males strutting their stuff and competing for the attention of local females are often seen frequenting bars and clubs after darkness falls in human cities. This is colloquially known as 'going out'. In non-human species, the gathering of multiple males in one location to compete for mating rights is called lekking.

MATING BATTLE

During the rainy season, male hercules beetles gather around attractive females, swapping pheromone signals to display their interest. But among a mélée of beetles, all armed with long, horn-like pincers, these males must **fight for the female's attention**. The aim of this wrestling match is to grab the rival male between his two horns and flip him over or slam him to the ground. Considering hercules beetles can lift weights hundreds of times their own bodyweight, this doesn't seem too difficult a task. However, beetle pairs are often evenly matched, and their struggles can be quite extended. Eventually one male will triumph – usually the male with the largest horns – and he is rewarded with the opportunity to mate with the female.

SEEING EYE TO EYE

Male stalk-eyed flies also compete for access to females, but in most cases they avoid the need to fight by comparing the lengths of their stalked eyes instead. The male with the shorter eyestalks always concedes, gracefully. Only if their eyes are exactly the same length will males enter into physical combat. Much like two intoxicated human males, the flies will first square up to each other, circling and bobbing, hoping the other will back down before having to throw any punches. If this is unsuccessful, the flies will resort to fisticuffs, punching out with their first pair of legs and jabbing towards their rival's head.

DON'T LOSE YOUR HEAD

Although access to a female for mating is the ultimate goal for all males during courtship, in some species it pays to exercise a little caution when choosing a mating partner. Hungry female praying mantises have been known to devour males during copulation. Though this behaviour is uncommon, the male still approaches with care, making all the right moves just in case.

BONDAGE SPIDER

For many species of spider in which females are larger and feistier than the males, distraction techniques are vital to prevent the males from becoming snacks after, or even during, mating. Some species wait until the female is tucking into a freshly caught meal. However, the male nursery web spider (above) has a more direct approach. Using his extra-long front legs, he wraps his female tightly in silk, preventing her from moving. Not only does this stop any unwanted sexual cannibalism, but it also allows the length of the sexual encounter to be extended, therefore increasing the amount of sperm he can transfer.

ENSURING PATERNITY

Everyone has had a friend who falls into paranoia and obsession when they enter into a new relationship. At dinner they are glued to their phone, your Facebook feed is clogged with their couple shots, and they become incapable of holding a conversation unless it involves their new love interest. In the invertebrate world, obsessive relationships are taken to even further extremes, from chemical chastity belts to traumatic insertion of their own sperm into the gonads of rival males.

VIRGIN MATING

A male heliconian butterfly ensures the chastity of his mate by waiting outside the chrysalis of an unhatched female. Virgin butterflies are such highly valued prizes that many males vie for the chance to copulate with the same female, in fights that can last up to two hours. In his eagerness, the winning male will sometimes even insert his abdomen into the newly hatching pupa and begin to copulate with the female before she has fully emerged.

SPECIES PROFILE

HELICONIUS CHARITHONIA

Common name: Zebra longwing butterfly
Distribution: North and South America
Special skill: After mating, the male passes the female a spermatophore (the parcel containing his sperm), which contains an anaphrodisiac – a pheromone that reduces her attractiveness to subsequent males.

NOT-SO-BRIEF ENCOUNTER

Male soapberry bugs have a reputation for being clingy, especially in the northernmost parts of their range. In those areas, where males can outnumber females by over five to one, they don't take any risks over the paternity of their female's eggs. Although the male releases his seminal fluid as quickly as 5 minutes into intercourse, he remains attached to her for up to 11 days. During this time, he will briefly remove his genitalia so that the female may lay her eggs, then he will immediately re-penetrate her, clasping on tightly with his mating hooks.

TOTALLY DEVOTED

Having a loyal partner makes it much easier to ensure that you really are the offspring's father. Many flies, including mosquitoes, can enforce their partner's fidelity through proteins in their semen, which make the females less interested in pursuing other suitors. And if that wasn't enough, many species also block the female's genital opening with a 'mating plug': a jelly-like obstruction that will only be cleared when she lays her eggs.

AMAZING FACT!

Some species focus on preventing females from mating with other males, but cave bat bugs get ahead of the game by inserting their sperm into the reproductive tract of other males. So when the males they target next mate with females, they release another bug's sperm!

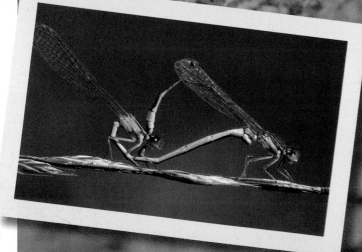

SPERM COMPETITION

Female dragonflies mate with multiple males, but it's the sperm of the final male she mates with before laying her eggs that will fertilise them. Often males will physically fight off rivals, but other males compete in a sneakier way. Some species have barbed penises, which they use to scrape out the semen of previous partners before mating. Others overload the female with vast quantities of seminal fluid in order to dilute competing sperm.

ANATOMY

Invertebrates copulate in an unbelievable variety of ways, from coyly firing love darts to shyly dropping sperm parcels, and from brutal skewering to partial and complete disembowelment. But what the majority of these encounters have in common is a male's protruding organ penetrating some part of his lover's anatomy. We loosely refer to these organs as penises.

FRUIT FLY

Nothing says intimacy like a spiny-headed penis. Sadly, for female Fruit flies this intimacy is enforced rather than volunteered. The spines on the Fruit fly penis – which are arranged in a variety of patterns depending on the species – pin the female firmly in position during their 10 minutes of intercourse.

SPECIES PROFILE

DROSOPHILA BIFURCA

Distribution: Worldwide

Special skill: These 2mm (1 1/16in) long fruit flies can produce sperm that are more than 6cm (2in) long – a thousand times longer than a human sperm.

BEAN WEEVIL

Unlike the fruit fly, whose spines allow him to hold onto the female, the bean weevil (left) uses his spikes to ensure deeper penetration of his sperm, right into the female's body cavity. It is thought that a chemical in the male's semen increases female fertility if it makes it into her haemolymph – a fluid similar to blood found in some invertebrates.

DAMSELFLY

The curved horns mounted on the end of the damselfly's penis are used to scrape away rival sperm from the female's reproductive tract. This sperm scrubbing brush is so effective that it can remove between 90 and 100 per cent of the competition in less than 30 seconds.

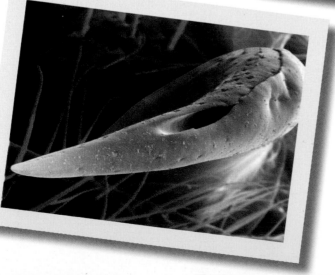

COMMON BEDBUG

Despite the fact that his female counterpart has a perfectly functional reproductive tract, the male common bedbug prefers to use his lance-like penis (shown left) to traumatically inseminate her. In other words, he stabs through her exoskeleton with his penis-blade and releases his sperm into her abdomen. So highly evolved is the bedbug penis, it is also able to 'taste' whether the female has recently been mated and adjust the length of copulation accordingly.

NUDIBRANCH

All nudibranches, including the mating pair shown above, are hermaphrodites: in other words, they are able to accept and deliver sperm because they have both male and female organs. To ensure that the sperm they deliver has the highest chance of being used to fertilise their partner's eggs, they have backward-facing spines, which scrape out competitors' sperm as they disengage. To prevent accidental fertilisation with their rival sperm, they bite off the contaminated penis and grow themselves a new one, 24 hours later.

BEE

The male bee is called a drone. His primary role in life is to fertilise the queen. Thus, after the deed is done, he is useless to the hive. That's pretty convenient, considering that during ejaculation his penis and associated abdominal tissue are ripped from his body as he falls to his death. The severed penis doesn't even prevent further drones from mating with the queen, though it may momentarily prevent leakage of his semen.

SPECIES PROFILE

PERIPATOPSIS SPECIES

Common name: Velvet worm

Distribution: South Africa

Special skill: Places its sperm directly onto the female's skin, which breaks down underneath it. This allows the sperm to be absorbed into the female's bloodstream and delivered to the ovaries.

LOVE SONGS

I once woke from a terrifying dream that a rogue helicopter was descending on my house, only to realise that my Goliath beetle had escaped from his tank and that the infernal buzzing was the vibration of his wings as he flew around my bedroom. Despite their small size, invertebrates are capable of making an incredible cacophony of sounds. Although perhaps not music to the human ear, these noises are used to locate, summon and arouse potential partners in a variety of marvellous ways.

MOSQUITO

While most people are familiar with the irritating drone of a nearby mosquito, fewer will know that some mosquitoes can change the frequency of their buzzing in response to the individuals around them. On approaching a potential mate, both male and female will alter their frequencies in order to find a pitch at which they can duet. If a match is made, they will mate.

SPECIES PROFILE

AEDES AEGYPTI

Common name: Yellow fever mosquito

Distribution: Worldwide in warm climates

Special skills: Carries both dengue fever and yellow fever.

AMAZING FACT!

A yellow fever mosquito put me in hospital for a week in Borneo after I contracted dengue fever!

DEATHWATCH BEETLE

Historically, in British, European and US folklore, the tapping sound of the deathwatch beetle (right) was considered **an omen of death**. In reality, it is male Deathwatch beetles that cause the noise by knocking their heads on wood in order to attract females. The females feel the vibrations with their feet and – if impressed – respond by knocking back.

MOLE CRICKET

As with most other crickets and katydids, male mole crickets (left) call their mates by stridulation – rubbing their wings together to make a chirping sound. They also have a unique and ingenious method of increasing the volume of their calls. They build specialised, horn-shaped burrows, which amplify the sound of their songs.

GRASSHOPPER

The grasshopper's huge hind legs are lined with raised pegs. He creates his discordant tune by rubbing these pegged legs across his hardened forewings. Fortunately, the female doesn't care that his melody is basic as her ears are simple membranes on her abdomen, which can only detect rhythm, not pitch.

CICADA

Most of the cicada's life is spent underground as a nymph. When the adult cicada hatches, its sole aim is to reproduce, meaning that finding a mating partner is a matter of urgency. The male cicada has specialised ribbed membranes, called tymbals, on either side of its abdomen. These allow him to make one of the loudest sounds of all insects, at more than 100 decibels. The tymbals vibrate rapidly to make a deafening chirp.

SPECIES PROFILE

MAGICICADA SEPTENDECULA

Common name: Periodical cicada

Distribution: North America

Special skill: This species of cicada spends the first 17 years of its life living underground as a nymph, before emerging en masse to reproduce.

FANCY FOOTWORK

In many species of invertebrate, a single population can number in the thousands. Choosing the best suitor in such an enormous group can be an overwhelming task. For some species, prowess on the dance floor can be a free ticket to reproductive success. For others, in which unconvinced females feast on their disappointing suitors, it can be a literal dance with death.

PROMENADE À DEUX

At first glance, the scorpion mating ritual may appear the most romantic of all courtship dances. They move together gracefully, pincer in pincer, even sharing the occasional 'kiss' of their front mouthparts (the chelicerae). But all is not as it seems.

After locating his dancing partner through a combination of vibrations and pheromone cues, the male grasps the female's pincers (pedipalps) in his own, thus restraining her primary weapons. Some species, in which the males have elongated tails, also land 'mating stings' on the female's back. Others **deliver a venomous 'kiss'** with their chelicerae. Once the female is sufficiently physically and chemically restrained, the male can overpower her and take the lead. He guides her in a dance-like motion,, pushing and pulling her across the uneven ground. They spin and glide, pedipalp in pedipalp, until he finds a suitable position to place his sperm packet (spermatophore). Once this is safely delivered, he guides the female over it, hoping that she will accept and take it into her genital opening. When the dance is over, the male doesn't hang around. The hungry female can occasionally cannibalise her partners, so he makes a hasty retreat.

SPECIES PROFILE

HADOGENES TROGLODYTES

Common name: Flat rock scorpion

Distribution: Southern Africa

Special skills: Longest scorpion in the world. Uses its extra-long tail to sting females into submission.

DEDICATED DANCERS

As a male springtail, there are multiple ways to convince a female to pick up your sperm packet. If you are of the lazier species, this involves nothing more than depositing it on the ground, in the hope that your potential mate will wander past and take a fancy to it. Others will find a female and surround her with parcels of sperm, so that the only way she may escape is to pass over one of them, or to leap to freedom. There are also species that will forcibly drag their females over their spermatophores, in a ritual not dissimilar to the scorpion's *promenade à deux*. But for the most dedicated of springtails, a long and intricate dance is the only way to ensure a female's compliance (below right).

Dancing head to head, the male springtail must follow his female's lead. She will repeatedly spin away from him, as if to end their tryst. If the male persists, she will eventually allow him to maintain his position, which will usually result in her gracious acceptance of his spermatophore. If, however, she is still not convinced at this late stage, she will simply eat the male instead.

SPECIES PROFILE

FOLSOMIA CANDIDA

Common name: White springtail (above)

Distribution: worldwide

Special skill: Females of this springtail species can reproduce through parthenogenesis (they can produce female offspring from unfertilised eggs). This is only possible in females infected with a bacteria called Wolbachia.

DISCO SPIDERS

For peacock spiders, courtship is an aesthetic feast of colour and motion. Unusually for arachnids, these small jumping spiders have exceptionally good eyesight, seeing a wide range of colours, including ultraviolet light. The males use this to their full advantage, showing off their vibrant patterning to the females through **flashy and energetic courtship displays**.

There are many species of Peacock spider, each with their own unique colouring and individual moves. All species are found in Australia and have large, brightly coloured, flap-like extensions to their bodies. During their dances, they raise these flaps above their heads in a fan, much like the peacocks from which they get their name. Their extra-long third legs also feature heavily in their dances, which would not look out of place on a 1960s dance floor. Sadly for male Peacock spiders, the drab-coloured females of their species are extremely fussy. If she considers the dance to be unsatisfactory, or the male insufficiently coloured, she will attack and possibly even kill him.

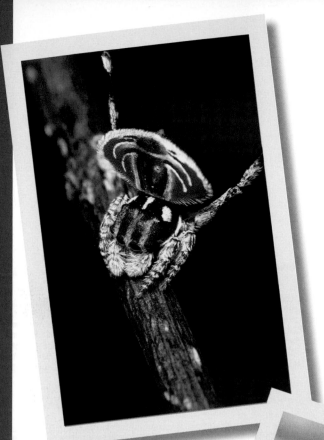

SPECIES PROFILE

COSMOPHASIS UMBRATICA

Common name: Tropical ornate jumping spider

Distribution: India to Sumatra

Special skill: Males have special scales on their body to reflect ultraviolet light. Females prefer the shiniest males.

SLUGS AND SNAILS

Slugs and snails are hermaphrodites which, as I explained on page 99, means they have both male and female reproductive organs. Yet despite having all the right bits to produce a viable egg, slugs and snails do not self-fertilise. Instead, they come together in often-complex mutual exchanges of sexual material.

SLIMY SEX

Courtship is a long process in most species of snail. It usually occurs in three parts:

1 The couple touch each other all over with their tentacles. Then they push up into a slimy embrace, raising the soles of their feet off the ground, rocking to and fro.

2 There is an increased flow of haemolymph (their equivalent of blood) to their dart sacs, where they store spiky weapons made of calcium carbonate, affectionately known as love darts (see photo). The pressure sends the love darts flying into their partner's body at point-blank range.

3. The penises are brought out and sperm is mutually ejaculated into the vaginas.

LOVE DARTS

Snails have poor aim. Sometimes the love darts miss their targets completely. But sometimes they can pierce internal organs or travel right through the snail's body and come out the other side.

Like poison-tipped arrows, the function of the love darts is to introduce a chemical into the haemolymph of their partner, which makes them more receptive to storing sperm.

Although love darts are thought to improve snails' reproductive success, they do not release them every time they mate. Virgin snails do not dart during their first intercourse and snails that have had recent intercourse will not dart, as the love darts take a while to regrow.

AERIAL ACROBATICS

One of the most spectacular mating displays in the animal kingdom is that of the leopard slug. Usually observed at night, this bizarre ritual begins when one slug produces a special slime containing chemical signals that advertise to all the other nearby leopard slugs that it is ready to mate. When a consenting leopard slug picks up this trail, it follows the slime until it reaches its suitor, which it nibbles gently on the tail. The pursuer may then spend several hours tickling its partner's body with its tentacles. Eventually, they head upwards, ascending a tree, wall or overhang, in order to find a suitable location from which to dangle for the main act. At this point they descend on a stringy cord of mucus, which can reach 1m (3.3ft) in length, gracefully entwining their beautifully striped bodies. Slowly they begin to turn outwards, their long, blue-tinged penises extended from the right side of their heads. The penises begin to entwine and then fan out, flower-like, before each slug releases its sperm packet into the other.

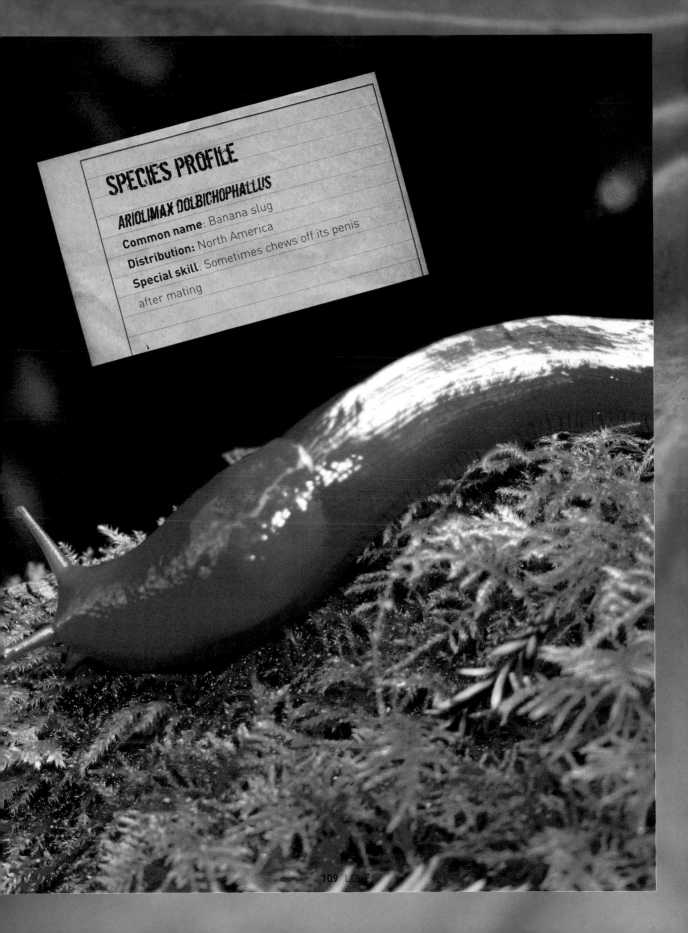

SPECIES PROFILE

ARIOLIMAX DOLBICHOPHALLUS

Common name: Banana slug

Distribution: North America

Special skill: Sometimes chews off its penis after mating

CARING FOR YOUNG

When human babies are born, they can do little for themselves except breathe, eat and defecate. To survive they require a significant degree of parental investment and care. Not all animals are born this helpless. Many invertebrate babies are on their own from the second they hatch from their eggs. They must learn to find food, evade predators and develop into adults all by themselves. Some luckier creatures are left gifts of fungus, rotting carcasses or freshly rolled poo to welcome them into the world.

BIRTHDAY PRESENTS

In my garage I still have a box full of bizarre objects that I was gifted at my christening, including Victorian cutlery, outdated coinage, gilded eggcups and other paraphernalia that is equally unhelpful to a human infant. In the invertebrate world, birthday gifts are often much more useful, and a lot more macabre.

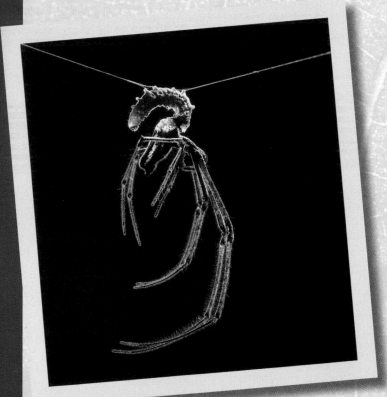

ZOMBIE SPIDERS

A Costa Rican wasp known as *Hymenoepimecis argyraphaga* gifts her offspring an Orb-weaver spider, as both a slave and walking meal. The pregnant (or 'gravid') wasp paralyses the spider and attaches her egg to its abdomen. When the larval wasp emerges from its egg, it spends a few weeks sucking the spider's hemolymph, until it is ready to moult to become a pupa (the stage between larva and adult). At this point, requiring somewhere safe to make its cocoon, the larval wasp injects the spider with a chemical, which alters the spider's web-making technique. Instead of making its usual flimsy web, the spider is forced to build a web of the wasp's bidding. This web is thick and strong enough to support the wasp cocoon. Once the web is built, the spider is no longer necessary, so the wasp kills it and sucks out its insides.

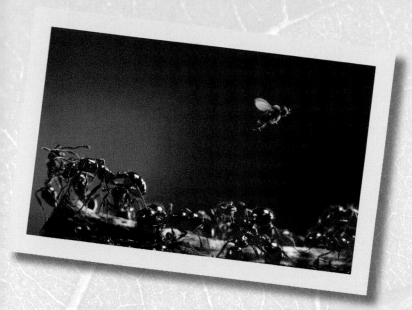

DELICIOUS ANT BRAINS

The tiny, humpbacked phorid fly looks a lot like a fruit fly. But the larvae of phorid flies could not have a more different diet from their harmless fruit-eating cousins. The adult female phorid fly injects her egg into a worker ant. After hatching, the larva makes its way to the ant's head, where it eats the brain and all the tissues inside. The ant's head usually falls off as a result, forming the perfect protective capsule in which the fly can become a pupa.

CATERPILLAR BODYGUARD

The *Glyptapanteles* wasp lays her eggs in the body of a geometer moth caterpillar, providing up to 80 offspring with delicious caterpillar flesh to feed on for their first meal. The wasp larvae mature inside the caterpillar through multiple moults, continuing to feed on its fluids until they are ready to become a pupa. As the baby wasps grow inside it, the caterpillar bloats and expands, until eventually the wasp larvae burst out of its skin en masse and start to spin their cocoons. Not only does the caterpillar survive this horrendous ordeal, but it sometimes even helps the wasps to build their cocoons by adding its own protective silk covering. Once all the pupating wasps are safely wrapped up, the caterpillar stands guard over them until they hatch, thrashing violently whenever a potential predator approaches. Finally, when all the wasps have successfully hatched, the caterpillar dies of starvation.

COCKROACH LARDER

The female emerald cockroach wasp – or jewel wasp – goes to great effort to supply her offspring with fresh food. This tiny wasp hunts down a common cockroach, often greater than six times her size. She stings it, firstly in the body to paralyse it, then directly in the brain. Using her highly sensitive stinger, the jewel wasp can locate the precise area of the brain that allows conscious control of movement and inserts her venom there. This venom renders the cockroach incapable of deciding which voluntary moves to make, though it's still entirely capable of making them. After all that effort, she refreshes herself by **chewing off the cockroach's antennae** and drinking its hemolymph (its equivalent to blood). Once revived, she tugs on the cockroach's antennae stub, encouraging it to follow her towards a recently prepared lair. Once inside, she lays her eggs on the still body of the cockroach and then leaves the burrow, blocking the entrance with pebbles. When the wasp larva hatches, it feasts systematically on the cockroach's organs, least vital first, to keep the cockroach alive for as long as possible. The final organ system to be eaten is the nervous system. Once this is gone, the cockroach dies. The wasp larva climbs into the empty cockroach shell, secretes an antimicrobial substance to sanitise it, and then pupates inside the carcass.

SPIDER FEASTS

Wasps in the Pompilidae family are known as spider wasps or pompilid wasps. Almost all of them capture and paralyse spiders to lay their eggs inside.

AMAZING FACT!

A tarantula hawk is a spider wasp that hunts tarantulas. This member of the Pompilidae family is considered to have one of the most painful stings known to man – level 4 on the Schmidt sting pain index (see page 49) – second only to the bullet ant.

BIRTHDAY CAKES

As most new parents know, sweet treats are the ultimate bargaining tool when it comes to convincing toddlers to follow instructions. We take it for granted that birthdays are intrinsically linked with overeating chocolates and cake. And no traditional children's party would be complete without jelly and ice cream. Some minibeasts also provide their babies with food on their birthdays, although there's not a Party Ring or Jammy Dodger in sight...

TROPHIC EGGS

Some species, such as the burrower bug, leave their offspring special eggs to eat, called trophic eggs. These are usually unfertilised eggs, which the mother lays to provide nutrition for her offspring. Trophic eggs are normally left close to the fertilised eggs, so that the offspring may devour them as soon as they hatch.

CORPSE STORE

Young burying beetles munch on decaying corpses. The parents will often fight rival pairs of Burying beetles in order to take charge of and bury a dead body, though sometimes (on particularly large carcasses) they will agree to share. In the case of a small animal, which a pair of Burying beetles has taken sole ownership of, the pair will work together to prepare it for their young. First, they will bite and scrape away all fur covering the body. They will then mould the body as best as possible into a ball. After this, they will begin to dig around the outline of the body until they have made a big enough hole to bury it. At this point, the female will begin to lay her eggs in the soil surrounding the body, and they bury her way into the centre of the corpse, making a depression in the top of the ball. Both male and female will wait for the larvae to hatch, at which point the female will call her offspring to the hole she has made in the corpse by stridulating (making a high-pitched noise by rubbing body parts together). While this happens, the male will often stand guard outside, if need be. The female will feed the larvae (making it easier to swallow) their diet until they are fully grown and ready to becoming a pupa.

WOOD-ROTTING FUNGUS

Sirex woodwasps have long, sharp ovipositors (tubes to lay eggs through), which deliver their eggs deep into wooden logs, where their wood-boring larvae should have plenty to feed on. But for a newly hatched wasp, wood can sometimes be a little tough to swallow. Luckily, adult Sirex woodwasps have a clever way of making their offspring's job a little easier. Some species of woodwasp deposit wood-rotting fungus alongside their eggs, which acts as a food source for the young wasps, as well as softening the wood around them. The adult female wasp carries the fungus in sacs at the base of her ovipositor.

AMAZING FACT!

Sadly for the woodwasp, its seemingly well-protected egg-laying site is easily parasitised by a species of ichneumon wasp, which has an equally long, hair-like ovipositor. When she discovers the location of a woodwasp larvae, she passes her ovipositor through the solid wood and deposits her own egg onto the woodwasp larvae, where it eventually hatches and eats the young woodwasp alive.

PROBIOTIC POO

When brown-hooded cockroaches hatch, they are unable to digest cellulose, the major component of the wood on which the adults feed. To be able to digest it, young brown-headed cockroaches must feed on their parents' faeces, which contains cellulose-digesting protozoans (single-celled animals). Without eating the faeces, the cockroach offspring cannot digest their food and would therefore die.

DUNG BALLS

Like the brown-hooded cockroach, dung beetles also provide their offspring with a meal of faeces. In this case it is not their own dung, but that of another creature altogether – usually a large herbivore. When they find a ball of dung, the male and female dung beetles work together to transport it to a place where the ground is soft. Here they bury it underground and the female lays her eggs inside it. When the larva hatches, it feasts on the surrounding dung.

NESTS

Growing up as a young invertebrate is tough. Such a tiny creature in an enormous world is extremely vulnerable. For those species whose parents don't hang around to look after their young, there needs to be another method of ensuring some of their brood survive. For certain species, this means producing abundant babies, in the hope that this increases the chances of at least some young surviving. Others put extra effort into providing safe nests, where the eggs are sheltered from predators, at least until they hatch.

BIVOUAC

During their migratory phase, army ants are constantly moving in search of new food. As they don't have time to build a new nest every day, they create temporary structures called bivouacs (right). The bivouac is a large protective ball, constructed of worker ants' bodies and linked at the legs and mandibles. These balls can often be seen hanging from tree branches, with workers on the outside and the queen and her offspring safely contained in the centre.

OOTHECA

The female praying mantis often lays hundreds of eggs in a foamy egg sac called an ootheca (left). Most of the offspring will not survive once they hatch, so it is vital that they are given a decent chance to get to that point. To protect her eggs from predators, the mantis lays them inside the protein-rich foam, which hardens around the eggs inside.

EGGS ON STALKS

Green lacewings lay their eggs on the tips of silken threads (right). These egg-topped bristles hang, suspended in the air, hiding the nutritious parcels of protein from passing predators.

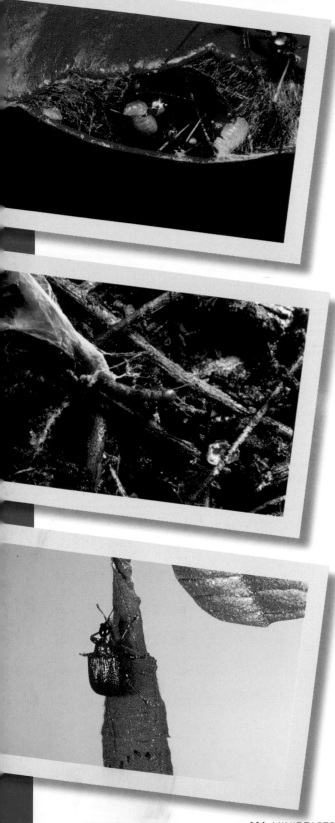

WORKING FOR THEIR KEEP

Adult green tree ants cannot produce silk, but their larvae can. In order to build safe nests for the colony to live in, they use their offspring as living pots of glue. A first wave of worker ants locates a suitable leaf, pulling its edges together, creating the beginning of a safe nest site within (left). A second wave of workers then arrives, wielding the silk-producing larvae, which are encouraged to start releasing silk by a pinch from the adult carrying them. As the silk is squeezed out of the larvae, it is passed across the leaf edge, until the leaf is held in place. This is repeated with multiple leaves, until the nest is completed.

WEB GALLERY

Silk is usually associated with spiders and caterpillars. But the spinning skills of the little insects known as webspinners rival all other web-makers. Webspinners produce silk from glands on their front legs. They use this silk to build vast tubes and tunnels of web in which they live. These strong, waterproof tubes are called galleries, and can often reach up tree trunks to heights of over 3m (10ft). Young may remain in the colony for their whole life.

LEAF ROLLERS

A female leaf rolling weevil (left) locates a feeding plant that she knows her newly hatched offspring would be happy to eat. Then she chooses a leaf and chews a hole in its stem, severing its water supply. This makes it less bulky and easier to roll. She makes small holes right across the area of leaf that is to be rolled, making it floppy and easy to manouevre. When the leaf is sufficiently flaccid, she positions herself, straddling the edge of the leaf, and begins to roll it towards her, tucking it in with her snout as necessary. Once she has created a tightly rolled cylinder, she crawls inside it and deposits her eggs into safety.

MUM'S THE WORD

In those species that don't just drop their eggs and run, it is usually the female that provides the majority of the parental care. As she lays the eggs, she can be certain that they belong to her, and in a world so full of dangers, it's often the best way to ensure that as many of her offspring as possible survive.

WHIP SPIDER

Mothers of tiny whip spiders carry around not only their egg sacs but also the offspring that hatch out of them (right). When the little whip spiders, called praenymphs, first hatch, their exoskeletons are not sufficiently developed to allow them to walk, so falling off their mum would mean certain death. Luckily for them, she keeps reasonably still during this vulnerable phase. When at last the praenymphs are ready to moult, the mother prepares by locating a vertical surface. The praenymphs take it in turns to move to the very end of her body, shed their baby skin, then leave the safety of their mother's back.

THORN BUG

Although the female thorn bug, or treehopper, has no real weapons to speak of, she is resolute in her desire to protect her offspring. From the moment she lays her eggs, which she places carefully in rows along the bark of her food plant, she devotes all her time to their protection. She straddles the eggs for two weeks, only moving just before they hatch to make slits in the woody plant stem, from which her newly hatched nymphs will feed. Once her young have hatched, the mother bug keeps them closely huddled together, herding them back with gentle strokes if they begin to stray too far (left). She is assisted in her vigil for potential threats by the nymphs themselves. If any of her brood senses a threat, it begins to vibrate, passing the message Chinese whispers–style through the mass until it reaches their mother, who will lash out with her wings and powerful hind legs.

NURSERY WEB SPIDER

The female nursery web spider carries her huge, globular egg sac around with her in her jaws (below left), preventing her from eating until the egg sac hatches. When she decides the time is right, she safely places the egg sac down, often on a leaf or branch, then spins a nursery web dome around it (below right). To allow the spiderlings to escape from the egg sac, she gently teases open its threads. If she doesn't do this, her young will remain inside, where they will die. Once her offspring have safely emerged, they will remain inside the nursery web until their first moult, when they will disperse. Throughout this time, their mother will be on guard close by. Athough she will have no physical interaction with her offspring, she will watch, protecting them from danger.

EARWIG

Female earwigs are fantastic mothers. After laying her eggs in a meticulously prepared underground chamber, the female devotes all her time to caring for her eggs. The chamber is often damp – a perfect habitat for mould. Therefore she systematically moves her eggs from one spot to another, licking the entire surface of every egg to prevent fungal growth. For around a week, the female earwig does nothing but dote on her eggs, only eating the occasional egg that has become non-viable. Once the nymphs hatch, the mother continues to care for her young. Much like bird chicks, the baby earwigs nestle under the mother's body, only emerging when they are hungry to nuzzle her mouthparts, begging for food. At their demand, the mother regurgitates food and saliva into their mouths. During this time, she fiercely defends her underground lair, aggressively attacking any creature that dares to come near. Sometimes, the effort of defending and providing for her offspring becomes too much and the mother dies. Yet even in death she provides for her young, which will not hesitate in devouring her carcass.

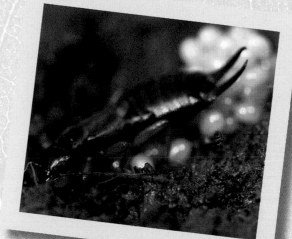

CENTIPEDE

These invertebrates are famed for their ferocity and hostility in the face of predators and prey alike. But centipede mothers are among the most gentle and attentive of any described in the invertebrate kingdom. The mother curls herself protectively around her eggs 24/7, starving herself for the 50-plus days it may take her young to hatch and dedicating herself completely to the stroking, cleaning and turning of her eggs. Of course, if a predator approaches, the female centipede will turn her well-documented aggression on whichever animal dares to disrupt her nursing.

DEVOTED DADS

While it has become normal for modern human males to play an active part in the upbringing of their offspring, there are only a handful of invertebrate species in which males play any role in parental care. This is partly because, in order to make parental care worth their while, males must be able to prove their paternity. Most species in which paternal care occurs fertilise the eggs immediately before taking charge of them, thus ensuring a safe investment.

TROPICAL HARVESTMAN

Male tropical harvestmen (*Zygopachylus albomarginis*) meticulously prepare mud nests (right) in which to raise their offspring. Sometimes they build these nests themselves; other times they fight rival males for nests they have already made. Once ownership is established, the nest is fastidiously prepared. Fungus is removed, holes are repaired, and the site is fiercely guarded against other harvestman and ants.

Multiple females may visit the harvestman's nest. They mate with the male, deposit their eggs inside the cave and then leave. He will indicate the vacant area into which the female is to lay her eggs by tapping first her body, then the floor of his nest. Any individual harvestman's nest may therefore contain multiple eggs from multiple mothers of various ages. The male protects them all. But if a female tries to lay eggs in the harvestman's nest without mating with him, he will not protect them. Any eggs of uncertain paternity will be eaten immediately.

GIANT WATER BUG

After mating, the female giant water bug (left) sticks her eggs to the male's back. This guarantees that they will be properly aerated and protected until they hatch. In order to ensure paternity of the eggs he is carrying, the male insists on repeated copulations before accepting the eggs. Once mating is over and the eggs are safely attached (a successful male can have a dense carpet of up to 150 eggs on his back), he sets about his fatherly duties. In order to provide sufficient oxygen flow to the eggs, the male water bug does underwater push-ups, forcing aerated water to flow over his back. He also makes periodical trips to the surface, to expose the eggs to fresh air.

BRACHYCYBE MILLIPEDE

Parental care in the *Brachycybe* genus of millipedes is undertaken entirely by the male. As soon as the female deposits her eggs, often on the underside of a decaying log, the male millipede coils his body around them (below). The purpose of brooding the eggs in this way is probably not to protect them from predation, as the male does not respond aggressively to disturbance, but rather to prevent the eggs dying by fungal infection. In experimental conditions, *Brachycybe* eggs that were not guarded by a male often succumbed to mould growth, whereas those that remained with their father did not.

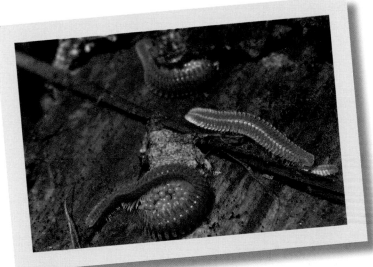

SEA SPIDER

Once the female sea spider has released the eggs from her ovaries, located on her upper hindlimbs, her role in parenting is over. The male collects the eggs and fertilises them, then secretes a glue in order to stick them to a pair of specially modified legs, called ovigers (below). Male sea spiders can be found carrying up to 1,000 eggs on each leg. The male carries the eggs in this way for several weeks, until they hatch. In many species, the hatched offspring still remain with their father until they are big enough to survive alone.

CUCKOOS

The most energy-efficient way of bringing up children is to get someone else to do it for you. If you have a fail-safe method of ensuring that other 'parents' will care for your children as their own, then you are free to make more babies and probably live longer due to the reduced stress levels. The most famous example of this behaviour, often known as brood parasitism, is the cuckoo bird, which places its eggs directly into the nest of another bird. The egg hatches and the cuckoo chick demands to be fed by the unwitting foster parents. Similar behaviour occurs in the minibeast world, with some species demanding direct parental care from another species. Others simply steal the food resources carefully prepared by the parents of another species for their own offspring.

ANT NANNIES

Some thorn bug mothers have learned to improve their reproductive success by leaving their first set of offspring in the capable hands of ant nannies. The adult thorn bug entices the ants by secreting an attractive concoction of sugary, protein-rich water. Once drawn by the mother's ant-attractant, the ants turn to the nymphs, which also produce delicious honeydew, though in smaller quantities. Soon the ants become so dependent on the sweet liquid secreted by the thorn bug and her offspring that they will ferociously defend any predator that threatens the thorn bug brood. Trusting in the ant's dependence on the honeydew of her offspring, the mother thorn bug is happy to leave her nymphs under their sole guardianship. She slopes off, shirking her maternal duties, and produces another clutch of eggs in a different location.

SPECIES PROFILE

POLYERGUS SPECIES

Common name: Amazon ant

Distribution: Northern hemisphere

Special skills: Steals the offspring of wood ants and raises them as slaves to clean the nest, feed the workers and queen, and raise their offspring.

BEE MIMICS

Blister beetle larvae have a remarkable method of finding their way into a nest in which they don't belong. The first stage of their deceit is to attract a male solitary bee. The beetle larvae do this by clustering into a bee shape (see right) and emitting a pheromone, which mimics that of a female bee. This attracts a mate-seeking male, who will attempt to mate with the mass of beetle larvae. As soon as the male bee makes contact with them, the blister beetle larvae attach themselves to his body. Once the male bee finds a real female with to copulate with, the beetle larvae quickly transfer from his body to hers. Eventually, the female returns to her nest, where the beetle larvae dismount. Once in the nest, the beetle larvae feast on the pollen that was collected by the female for her own offspring.

MASTERS OF DISGUISE

The giant prickly stick insect displays extraordinary costume skills at multiple stages of its life cycle. This starts with the egg, which the female fires out with considerable force, sending it far from her piles of faeces, which may attract egg predators. The egg resembles a seed and is plugged with a layer of lipid (a fatty substance that doesn't dissolve in water), which is irresistible to spider ants (below right). When worker ants discover the delicious egg, they carry it back to the ant nest, where the outer layer is devoured. Once they have removed the edible layer, they dump the rest of the egg on the ant waste-pile, where it is protected from predators and forest fires. Eventually the baby stick insect hatches, in the second stage of its disguise (below left) – it looks exactly like a spider ant, even mimicking their rapid, frantic movements. The purpose of this impersonation is twofold: first, it allows the stick insect to escape the ant's nest unharmed; second, the orange-and-black patterning makes them look poisonous to potential predators. Once the stick insect nymph escapes the ant's nest and makes its way into the treetops, it moults out of its ant costume and takes on a more traditional, stick-like appearance.

GLOSSARY

alkaloid naturally occurring compounds, made by many plants and some animals, which are often poisonous to humans and other animals

amino acids simple organic compounds, which are used to build proteins

anaphrodisiac a chemical that reduces sexual desire

anticoagulant a chemical that prevents or slows blood clotting

aposematism the use of bright colours to warn predators that an animal is **poisonous** or tastes bad

appendage a body part that projects from the main body trunk, such as an arm, leg or sexual organ

biomass the total quantity or weight of organisms in a given area or volume

caste system the splitting up of insects into groups depending on their body shape and what job they do

chelicerae part of the mouthparts of arachnids, usually positioned in front of the mouth and next to/inside the **pedipalps**

chitin a hard material found in minibeast exoskeletons

chordates animals of the large phylum Chordata, including all vertebrates, along with sea squirts and lancelets

class a taxonomic category that ranks above **order** and below **phylum**

cnidarians aquatic invertebrate animals of the phylum Cnidaria, including sea anemones, corals and jellyfish

commensal a type of symbiotic relationship between two species in which one species benefits from the relationship while the other species is unaffected by it

dart sac an **appendage** in certain land snails that is used to store love darts; these appendages can be turned inside out

ecdysis the scientific term for shedding the old skin

echinoderms marine invertebrates of the phylum Echinodermata, including starfishes, sea urchins and sea cucumbers

exoskeleton the hard, protective covering of some minibeasts, such as arthropods

family a taxonomic category that ranks above genus and below order

genus a taxonomic category that ranks above **species** and below **family**

gravid carrying eggs or young; another word for pregnant

gynosome the sexual organ that a female uses to penetrate a male

haemolymph fluid found in the circulatory system of some invertebrates, very similar to blood

herbivorous feeding on plants

hermaphrodite an animal with both male and female reproductive organs

histamine a chemical released by cells, often during an allergic reaction

hydrothermal vent an opening in the sea floor, usually caused by an underwater volcano, which spews out boiling hot, mineral-rich water

invertebrates animals lacking a backbone, including arthropods, **molluscs**, annelids, and so on

instar a stage of insect growth defined by how many times the insect has shed its skin

kingdom the highest category in taxonomic classification

larvae the stage of minibeast growth after hatching from an egg and before becoming a pupa

lekking when males gather together to compete and display for the attention of females

lipid a fatty substance that does not dissolve in water

mandibles minibeast mouthparts

mutualistic a type of symbiotic relationship between two species in which both species benefit from the relationship

nematodes also known as roundworms, this group of worms constitute the phylum Nematoda

order a taxonomic category that ranks below **class** and above **family**

oviger legs that are specially modified for carrying eggs

oviposition laying eggs

ovipositor a tube used to lay eggs through

palp *see* **pedipalp**

parasite an animal that gets its food from living on or inside another animal

parasitic a type of symbiotic relationship between two species in which one species benefits from the relationship while the other species suffers as a result of it

parthenogenesis when an egg hatches without being fertilised

pedipalp part of the mouthparts of arachnids, sometimes modified for sensing or grabbing (often referred to as pincers or palps); usually positioned next to/outside the **chelicerae**

pheromone a chemical that can affect behaviour and development

phloem a tube that moves food around the plant

phylum a taxonomic category that ranks above **class** and below **kingdom**

pincer *see* pedipalp

poisonous produces a substance that is harmful when touched or eaten

protozoan a single-celled animal

pupa the stage of minibeast growth after being a larvae and before becoming an adult

pupate become a pupa

raptorial adapted for grabbing hold of prey

rostrum a beak-like projection from the head of some invertebrates

roundworms *see* **nematodes**

serotonin a chemical that sends messages between nerve cells

species the principal taxonomic unit, which ranks below a **genus**

spermatophore a sperm packet

sponges aquatic invertebrate animals of the phylum Porifera

sterol a type of lipid (*see* **lipid**)

stridulation producing a high-pitched sound by rubbing body parts together

thanatosis the act of pretending to be dead to deceive predators

trophic egg an unfertilised egg left as food for newly hatched young

venomous produces a substance that is harmful when injected

AUTHOR ACKNOWLEDGEMENTS

An enormous thank you to my incredible fiancé, Dan. Without the cups of tea, dinners delivered to my desk, patient readings and re-readings of text and an infinite supply of cuddles when the long vet days and longer book-writing nights became too much, none of this would have been possible. Thanks also to all the family and friends that have put up with years of log lifting, leaf turning and mud digging in search of new and exciting minibeasts. Thanks to my dad for bringing a world of incredible creatures into my own back garden and to my mum for putting on a brave face when the odd beastie made it back to her house. Thanks to Gill, for all your help, guidance and support through every step of my writing journey and for helping me to believe.

Finally, thanks to Julie Bailey and the team at Bloomsbury Wildlife for encouraging me and supporting me in the journey that led to the creation of this book. It could not have happened without their belief and guidance. And to Simon Buck, whose beautiful photographs show off my marvellous minibeast muses in all their glory.

PHOTO CREDITS

Bloomsbury Publishing would like to thank the following for providing photographs and for permission to reproduce copyright material within this book. While every effort has been made to trace and acknowledge all copyright holders, we would like to apologise for any errors or omissions, and invite readers to inform us so that corrections can be made to future editions.

Bloomsbury Publishing are very grateful to Simon Buck – simonbuck.com – for taking all the new photography with Jess French, as credited via the page listings below.

Abbreviated photo sources: GI = Getty Images; iS = iStock; NPL = Nature Photo Library; SPL = Science Photo Library; SS = Shutterstock.

Key to page positions: mi= main image; t = top; l = left; r = right; tl = top left; tr = top right; m = middle; ml = middle left; mr = middle right; bl = bottom left; br = bottom right.

Cover photos: both Jess French photos by Simon Buck. Species photos (from left to right and top to bottom), **front cover**: Marian Stoev/EyeEm/GI; Christian Senger/GI; Joel Sartore, National Geographic Photo Ark/GI; Tim Flach/GI; Tim Flach/GI; Steve Hoskins/ The Image Bank/GI; Brooke Whatnall/GI; BIOSPHOTO/Alamy; Targn Pleiades/SS; Aukid Phumsirichat/EyeEm/GI; blickwinkel/ Alamy; **spine**: t Glass and Nature/SS; b Simon Buck; **back cover**: tr Piotr Naskrecki/Minden Pictures/FLPA; ml Simon Buck; mr Ron Rowan Photography/SS.

Pages: 5 aSuruwataRi/SS; 6 (from left to right and top to bottom) Ethan Daniels/GI; REDA&CO/GI; Christopher Murray/EyeEm/ GI; ullstein bild/GI; Arterra/GI; BSIP/GI; mikroman6/GI; VWpics/GI; Dave and Les Jacobs/GI; Frank Greenaway/GI; Joel Sartore, National Geographic Photo Ark/GI; Nature Picture Library/GI; Steve Hoskins/GI; **7** Simon Buck; **8–9** Simon Buck; **10** t Nature Picture Library/Alamy; b Wally Sternberger/SS; **11** Dick Ercken/SS; **12** t Ingo Arndt/Minden Pictures/FLPA; m Biehler Michael/SS; b André De Kesel/GI; **13** t Richard Becker/FLPA; b Chris Moody/SS; **14–15** rtbilder/SS; **16** mi Jomic/SS; b Piotr Naskrecki/FLPA; **17** t kc_film/SS; b aaabbbccc/SS; **18** Mitsuhiko Imamori/FLPA; **19** t Ron Rowan Photography/SS; b Mit Kapevski/SS; **20** Minden Pictures/Alamy; **21** t Grant Heilman Photography/Alamy; b Deborah L. Matthews; **22** Simon Dannhauer/SS; **23** tl Paul Bertner/ Minden Pictures/FLPA; tm Hiroya Minakuchi/Minden Pictures/FLPA; tr Christian Ziegler/Minden Pictures /FLPA; b Mark Moffet/ FLPA; **24** t Backkova Natalia/SS; b National Environment Research Council; **25** Dr John Hall, University of Queensland; **26** tr The Natural History Museum/Alamy; bl The Africa Image Library/Alamy; **27** t Edward Parker/Alamy; b Minden Pictures/Alamy; **28** t dabjola/SS; b Piotr Naskrecki/FLPA; **29** t BIOSPHOTO/Alamy; mi Cosmin Manci/SS; **30** tl Ezume Images/SS; tr Aksenova Natalya/ SS; b Henrik Larsson/SS; **31** t Gianpiero Ferrari/FLPA; b Dave Nelson/SS; **32** up close with nature/GI; **33** t Gerry Pearce/Alamy; b Christian Musat/SS; **34–5** Simon Buck; **36** enciktat/SS; **38** t Herman Wong HM/SS; b Pedro Turrini Neto/SS; **39** mi Tomatito/ SS; **40** Pavel Krasensky/SS; **41** Erni/SS; **42** t jamesbenet/iS; b thatmacroguy /SS; **43** Sue Robinson/SS; **44** t Marco Maggesi/SS; b Auscape/GI; **45** Christian Vinces/SS; **46–7** Simon Buck; **48** t asawinimages/SS; mi aSuruwataRi/SS; **49** 1 Triduza Studio/SS; 2 Gerald A. DeBoer/SS; 3 Sean McVey/SS; 4 South 12th Photography/SS; 4+ Patrick K. Campbell/SS; **50** t Laura Dinraths/SS; b Dewald Kirsten/SS; **51** t ImageBroker/FLPA; b Premaphotos/Alamy; **52** Chris Mattison/FLPA; **53** t Paul Bertner/Minden Pictures/ FLPA; b Peter Waters/SS; **54** Lary Reeves/SS; **55** WildPictures/Alamy; **56** Premaphotos/Alamy; **57** Minden Pictures/Alamy; **58** Mark Moffett/Minden Pictures/FLPA; **59** t guraydere/SS; b BLUR LIFE 1975/SS; **60** Martin Prochazkacz/SS; **61** t Kevin Schafer/Minden Pictures/FLPA; m Atelopus/iS; b Marco Maggesi/SS; **62** Dennis W Donohue/SS; **63** t Nature Production/NPL; b Simon Buck; **64–5** Photo Researchers/FLPA; **66** Chien Lee/Minden Pictures/FLPA; **67** t Andrew Darrington/Alamy; b Robert Thompson/NPL; **68** t Tyler Fox/SS; mi Photo Researchers/FLPA; **69** tl Guillermo Guerao Serra/SS; br J-R/SS; **70** tl Photo Researchers/FLPA; mi Simon Buck; **72** tr yogesh_more/iS; ml Christian Hütter/Alamy; bml dbstudio/iS; br Brian Lasenby/SS; **73** t Muhammad Naaim/SS; mi up close with nature/GI; **74** phittavas/iS; **75** tl tinglee1631/SS; tr Liew Weng Keong/SS; b Premaphotos/NPL; **76** tl Sari ONeal/SS; br Elizabeth Spencer/SS; **77** tl Matyas Rehak/SS; tr Natali22206/SS; bl Arto Hakola/SS; br Klaus Kaulitski/SS; **78** tl Andrew Palmer/ Alamy; mi Avalon/Photoshot License/Alamy; **79** tl Simon Kovacic /SS; ml Edvard Mizsei/SS; mr Minden Pictures/Alamy; bl Michael DeGasperis/SS; br Panther Media GmbH/Alamy; **80** JakubD/SS; **81** t Pavel Krasensky/SS; b Cristian Gusa/SS; **82** tr Chekaramit/ SS; ml Lindasj22/SS; b Dennis van de Water/SS; **83** Arto Hakola/SS; **84** t Alex25/iS; b by pap/SS; **85** Vitalii Hulai/SS; **86** Alexandra Theile/SS; **87** Richard Becker/Alamy; **88** Simon Buck; **89** t Marek R. Swadzba/SS; m uhamad mizan bin ngateni/SS; b Hans Gert Broeder/SS; **90–1** Simon Buck; **92** mi Eric Isselee/SS; **93** khlungcenter/SS; **94** t Dietlinde B. DuPlessis/SS; b Marek Mierzejewski/ SS; **95** tr Michael & Patricia Fogden/FLPA; m Targn Pleiades/SS; bl Don Williamson/SS; **96** mi Marcel Jancovic/SS; b Fabio Sacchi/ SS; **97** t chakkrachai nicharat/SS; b NaturePixel/SS; **98** t Nicola Dal Zotto/SS; m Florian Andronache/SS; b POWER AND SYRED/ SPL; **99** DeeAnn Cranston/SS; **100** t Volker Schnaebele/SS; b Dr Morley Read/SS; **101** mi Bachkova Natalia/SS; b Tacio Philip Sansonovski/SS; **102** t Henrik Larsson/SS; m Fabio Pupin/FLPA; b PitukTV/SS; **103** t feathercollector/SS; m Jason Patrick Ross/ SS; **104** t Daniel Heuclin/NPL; b Audrey Snider-Bell/SS; **105** mr Mark Horton/Alamy; ml Henrik Larsson/SS; **106** t BIOSPHOTO/ Alamy; b Warut Prathasithorn/SS; **107** Chris Mattison/FLPA; **108** Wolstenholme Images/Alamy; **109** Sean Lema/SS; **110** Anand Varma/GI; **111** t Minden Pictures/Alamy; b Stephen Bonk/SS; **112** mr Glass and Nature/SS; bl Katarina Christenson/SS; **113** both Henrik Larsson/SS; **114** ml Melinda Fawver/SS; br Four Oaks/SS; **115** tr Mark Moffat/FLPA; ml Amelia Martin/SS; br Yongkiet Jitwattanatam/SS; **116** t Nature Production/NPL; m Premaphotos/Alamy; b Kim Taylor/NPL; **117** t Paul Bertner/Minden Pictures/ FLPA; b Pete Oxford/Minden Pictures/FLPA; **118** ml Jiri Prochazka/SS; br Roger Hall/SS; **119** tr Ian Redding/SS; bl SherSS/SS; **120** tr Alex Hyde/NPL; bl WOLF AVNI/SS; **121** t Sam McNally; b Premaphotos/Alamy; **122** tl Chien Lee/Minden Pictures/FLPA; br Pavel Krasensky/SS; **123** tr John Hafernik; bl Simon Buck; br Genevieve Vallee/Alamy.

INDEX